CONTENTS

Luton Sixth Form College
Bradgers Hill Road, Luton
Beds. LU2 7EW
Return on or before the last date stamped below

3-DAY ISSUE

AMOR MISTIAEN
BEN SMART
GEORGIE GORDON
DOUGAL MUNDELL
RONALD BADGER
B. TH. GRAHAM
ANNA CAMPBELL
SIONADH MANN
JOHN AUBREY
MARGARET HEWITT
BRIAN BALDWELL
TOM CARSON
MARGARET PETTIGREW
ANDREW McLEAN
LINDA GORDON
CRAIG RICHARDSON
MARIE WOODS
GORDON McKECHNIE
ANNE OOMS
EVAN BAKEWELL
SUZANNE DAVIES
ANNOUSHKA SHANI
RITA DONAGH
JULIE McLUCAS
TONY PATRICKSON
THOMAS JOSHUA COOPER
SIMON LAURIE
KEVIN FALCONER
ARCHIBALD BLACKADDER
ANNA BOLD
MARGARET BRIGHTON
JONATH HARLEY
ANDREW LOCKHART
HAZEL WILSON
MARIE NOST
GWAI GATES
SARA PUCILL
ELAINE GORDON
ISAAC AHMAD
KAREN STRANG
RONNIE HUGHES
DUNCAN McFARLANE
KASPER DAVIES
JOHN SIMMONS
MARCUS COLE
ADELE PATRICK
DAVE STOKES
DENIS LENS
BOBBY AIRD
GRANT McTAVISH
WILLIE McFADZEAN
KEITH INGHAM
CLAIRE RUDRUM
MARIAN GOODMAN
ELIZABETH WRIGHT
AMANDA McKITTERICK
MALVINA PUSEK
PETER McCAUGHEY
JANE ALSTON
ANDREW CLARKE

MARCUS BASTEL
PETER BAXTER
JIM CONNELL
JONNA KITARUTH
MARTIN GIBB
JOEL ABBOT
ANNE ROACH
RICHARD LAYZELL
STUART DONALDSON
MARK McCROSSAN
DAVID CORKER
CECIL ROACH
HILARY ROBINSON
ALISTAIR SMITH
JOHN McDOUGALL
JOAO OLIVIERA
BILL WRIGHT
LOUISE SHAMBROOK
TOBIAS REHBERGER
CLIVE KELLNER

DEBORAH COX
CLAUDE CLOSKY
ERIC TRONCY
RACHEL KHEDOORI
RUSSELL FERGUSON
SUZANNE ROGERS
CHRISTINE GORDON
SUE TAYLOR
LAURA HUDSON
GRAHAM GOUGH
JACQUELINE DONACHIE
PAUL KARLSEN
JOHN CUNNINGHAM
SUSAN BRECKENRIDGE
NICOLAS BOURRIAUD
CHRISTIANE BERNDES
SUSAN TURCOT
SISSEL TOLACE
STAN DOUGLAS
CORINNE GAMBI

HAMLYN
WOLKENHAUER
REFFIN
McCASKILL
CATON
HAZARD
FINLAY
OHLER
FRITH
TEN BERTHEUX
GINA STARR
SMART
AGNEW
LAS McINTYRE
ENRY
WRIGHT
OWMAN
COLIN
CORILLON
HILTY
JOHNSON
BIESENBACH
THORNHILL
ROSS
M PHELPS
DBB
ARTLETT
ACKSON
GILLIES
BURNS
MICHAEL
ELLY
CALLUM
WATSON
W JAMES
E ARCHER
ADIE
M HILL
RET HUTTON
HARRY KERR
TOM VAGUE
BOGDANOFF HOFFMAN
CAROLINE SCOTT
MONA HATOUM
NEIL MORRISON
ANNE McKINNON
LESLEY SMITH
JUDITH McDERMOTT
TONY JONES
RORY DONALDSON
CHARLIE McDONALD
JAYNE TAYLOR
PAT CONNOLLY
THOMAS KERR
PETER DAVID
JEANETTE BLACKWOOD
BERNADETTE MEEHAN
DOUGLAS MORRISON
MICHEL DUPUY
JAMES ROBERTS

Scottish National Gallery of Modern Art

recent acquisitions new
of contemporary British art

Edited by Alice Dewey

National Galleries of Scotland
Edinburgh 2002

Published by the Trustees of the
National Galleries of Scotland on
the occasion of the exhibition *New:
recent acquisitions of contemporary
British art* held at the Scottish
National Gallery of Modern Art,
Edinburgh from 6 July to
17 November 2002.

© Trustees of the National Galleries
of Scotland
ISBN 1 903278 34 1

Designed by Dalrymple
Typeset in Cycles and Myriad
Printed in Belgium by
Snoeck-Ducaju & Zoon

Front cover: Jim Lambie *ZOBOP*,
1999. Installation at The Showroom,
London, 2000

Back cover: Damien Hirst
Beautiful C Painting, 1996

Endpapers: Douglas Gordon
List of Names (Random)
1990–ongoing. Installation at the
Kunstverein, Hannover, 1998

new consists of a selection of works made by British artists since 1990, which have been acquired by the Scottish National Gallery of Modern Art. The exhibition includes paintings, photographs, sculptures, prints, drawings, artist books, a DVD projection, and installation works, and illustrates the breadth of artistic practice in the United Kingdom today. The works are displayed inside and outside the Gallery, often responding to particular spaces, like Douglas Gordon's *List of Names (Random)*, which has been installed from floor to ceiling in the stairwell. Recently sited outdoor sculptures, including Rachel Whiteread's *Untitled (Pair)*, are part of our continuing development of the grounds of both the Gallery of Modern Art and those of its sister building the Dean Gallery. An important part of the exhibition is a selection of items from our Special Book Collection which reveals the continuing role of artists in creating books.

Many of the works in **new** could not have been acquired without the generous financial assistance of various benefactors, including the Iain Paul Fund, the National Art Collections Fund, the Knapping Fund and the Patrons of the National Galleries of Scotland. Others have given works to the collection, including the Contemporary Art Society and Charles Booth-Clibborn of The Paragon Press. We are grateful to them all.

For their help in organising **new** we would like to thank Alice Dewey, Ann Simpson, Patrick Elliott, Nicole Giles, Alastair Patten, Agnes Valenčak-Krüger, Jim Wheeler and Judith Lowes. All the Gallery's curators have contributed entries to this catalogue. Many of the artists' galleries have provided vital information, in particular, Toby Webster and Danny Saunders of The Modern Institute, Swapna Tamhane of the Andrew Mummery Gallery and Patricia Kohl of the Stephen Friedman Gallery. Thanks are also due to Richard and Florence Ingleby of the Ingleby Gallery for organising the loan of *Love* by Alison Watt; this hangs in place of *Sabine*,

which we have lent to Dulwich Picture Gallery.

This catalogue has been produced by Janis Adams and Christine Thompson and designed by Robert Dalrymple.

new is the fourth exhibition at the National Galleries of Scotland which has been generously sponsored by Deutsche Bank, whose own collection of contemporary art was recently exhibited in the Dean Gallery. To the Chairman of Deutsche Bank Scotland, Lord Levene of Portsoken and its Executive Director, Stephen Connelly, we extend our profound thanks.

Finally we should like to thank all the artists represented in the exhibition, especially those who have assisted in the installation of their works.

MICHAEL CLARKE
Acting Director-General, National Galleries of Scotland

RICHARD CALVOCORESSI
Director, Scottish National Gallery of Modern Art

new demonstrates the variety and vibrancy that are hallmarks of artistic endeavour in Britain today. Deutsche Bank is pleased to support this exhibition, which acts as a showcase for the work of some of the very best British artists.

This is our fourth sponsorship of a National Galleries of Scotland exhibition and is part of a long-standing policy by Deutsche Bank to support contemporary art. Art plays a tangible part in our corporate culture with original work being displayed in all our buildings. This helps us to improve our working environment and creates an inspiring atmosphere for clients, staff and visitors alike.

Our sponsorship strengthens ties with the local community where our staff live. As a major employer in Scotland, we have a mutual interest in helping to maintain and improve the quality of life here. Our partnership with the Scottish National Gallery of Modern Art helps us to achieve this aim. We are sure that you will share our enthusiasm for the works on display and hope you enjoy the collection.

Deutsche Bank ◪

The Scottish National Gallery of Modern Art and its
sister building, the Dean Gallery, are part of the National
Galleries of Scotland, which also include the National
Gallery of Scotland and the Scottish National Portrait
Gallery. Since opening in 1960, the Gallery of Modern Art
has been committed to exhibiting and acquiring works by
living artists. Indeed, its first exhibition, in 1961, was of
the work of Henry Moore. The Gallery was faced with the
task of creating a permanent collection of international
stature, covering the period from about 1890, roughly
where the National Gallery of Scotland's collection
finishes, to the present day. Just over forty years later
the Gallery of Modern Art's collection stands at some
5,000 items.

Prior to the creation of a Gallery of Modern Art, the
National Gallery of Scotland rarely acquired the work of
living artists; there was an unwritten policy that an artist
had to have been dead for at least ten years to qualify for
inclusion in the collection. This 'rule' stemmed not from
a dislike of modern art, but was conceived as a way of
controlling the growth of the collection. A handful of
exceptions were made, most of them originating in gifts
or bequests, including the 1942 gift of Oskar Kokoschka's
Zrání, 1938/40, which was presented by the Czechoslovak
Government in Exile.

new occupies the entire ground floor of the Gallery of
Modern Art and spills out into the grounds. With one
exception (Tony Cragg's *Kolbenneblok*, 1989), all the works
have been made since 1990, and have been acquired since
1991. The exhibition demonstrates the diversity of ideas
and media used by artists working in Britain today, from
Sun, Sea and Sand, 1995 by Yinka Shonibare, an installa-
tion of 1,000 fabric-covered bowls, to the DVD projection
Breathing Space, 1997 by Smith / Stewart, to the doodles of
David Shrigley and the digitally altered photographs of
Wendy McMurdo. Contemporary art is often understood
to mean art made recently by young artists, but we have
also included the new work of an older generation –

including Eduardo Paolozzi, Alan Davie and Leon Kossoff – who continue to make remarkable work in their seventies and eighties. Since the founding of the Gallery, we have been committed to the acquisition of artist books, and an important part of **new** is a selection from this special collection.

Building a collection which represents over a century of artistic endeavour, and adequately covers painting, sculpture, works on paper, photography and video, in Britain and abroad, remains a tall order for the Gallery. We are, naturally, especially interested in Scottish art: more than a third of the artists represented in **new** were either born in Scotland or work here. This reflects the vitality of contemporary practice in this country, with exhibitions of Scottish art taking place as far afield as Sydney and Reykjavik. Recent developments have included the founding of major institutions, such as Dundee Contemporary Arts, and the development of the Centre for Contemporary Arts in Glasgow, as well as a range of artist initiatives, such as Transmission in Glasgow and Generator in Dundee.

The 152 works by eighty-two artists featured in **new** represent a decade of collecting contemporary British art. Without doubt large gaps remain, as inevitably our aspirations outstrip our means. Acquisitions are funded by a purchase grant which is shared with our sister institutions; the National Gallery of Scotland and the Scottish National Portrait Gallery. This is provided by the Scottish Executive and is enhanced by contributions from trust funds administered by the National Galleries of Scotland, as well as from various charitable trusts and grant-giving bodies. The Heritage Lottery Fund does not assist acquisitions of contemporary art, although it has helped us with major purchases of classic modern work. Many works have entered the collection thanks to contributions from the Iain Paul Fund. Iain Paul was a keen collector of work by Scottish artists, and following his death in 1995 a fund was established with the express purpose of buying works by Scottish artists for the Gallery's collection. He hoped that this act of benefaction might encourage others to take similar steps. Other contributions have been made by the Knapping Fund and the Patrons of the National Galleries of Scotland. The National Art Collections Fund has been a vital partner in acquiring contemporary works and went so far as to amend the rules of its constitution in order to support its first ever involvement with the commissioning of a new work, *Six Definitions* by Ian Hamilton Finlay, which was

installed in the grounds of the Dean Gallery in 2001. The Contemporary Art Society presented *Imagine You are Driving. 1.* by Julian Opie and *Self-portrait* by Helen Chadwick, the latter acquired by the Society through a grant from the Henry Moore Foundation. Several important works have been given to the Gallery by private benefactors, while our representation of contemporary British printmaking has been greatly enhanced by the generosity of Charles Booth-Clibborn of The Paragon Press. The money given by visitors to the Gallery, and placed in the donations box in the entrance hall, is used towards acquisitions, with the result that works by artists including Christine Borland, Howard Hodgkin, Jonathan Owen and Yinka Shonibare have entered the collection.

Several major recent acquisitions of contemporary British art are being shown for the first time at the Gallery in **new**, including Douglas Gordon's *List of Names, (Random)* which has been installed from floor to ceiling in the stairwell of the Gallery of Modern Art, Christine Borland's *Spirit Collection: Hippocrates*, which hangs from the ceiling, and Jim Lambie's ZOBOP which is laid directly onto the floor.

The continuing development of our grounds since the opening of the Dean Gallery in 1999 is also highlighted. Rachel Whiteread's *Untitled (Pair)*, which was acquired just before her 2001 solo exhibition at the Gallery of Modern Art, has recently been sited outside, as has Tony Cragg's *Kolbenneblok*. Ian Hamilton Finlay's *Six Definitions* and a work by Richard Long (to be installed summer 2002) have both been commissioned for specific sites in the grounds of the Dean Gallery.

Our acquisition of contemporary art represents a long-term commitment to the work of living artists and means that the works are held in trust for the nation and can be seen free of charge. We also operate an extensive programme of loans of works from our collection, to public institutions around the world. This enables many more people to view the works, and helps to promote the artists beyond Scotland.

Furthermore, we devote a large portion of our exhibition schedule to showing contemporary works which are lent to us. An interesting comparison with **new** is *The Vigorous Imagination: New Scottish Art*, an exhibition which was held at the Gallery of Modern Art in 1987. The Dean Gallery opened with a series of exhibitions of the work of living artists; Andreas Gursky, John Coplans and Gary Hume. At the same time as **new**, an exhibition of Howard Hodgkin's large paintings from 1984 to 2002 will be hung

in the Dean Gallery. In a perfect meeting of minds, Deutsche Bank, who has generously sponsored **new**, showed its collection of contemporary art in the same gallery in 2001–2.

The loan of works to the Gallery of Modern Art helps to fill inevitable gaps in the collection. In the contemporary sphere Jenny Saville's *Nude*, 1992, lent from the collection of John Rae, has proved particularly popular with visitors. This summer an exceptional group of contemporary works from another private collection, including important examples by artists such as Anselm Kiefer, Gerhard Richter and Jeff Wall, none of whom are represented in the collection, will be displayed.

new is not intended as a definitive statement about current British art. The funds available to the Gallery would preclude such a bold, perhaps foolhardy, undertaking. It is meant rather as a snapshot of what we have been collecting during a particularly rich and inventive period of artistic activity. Our work at the Scottish National Gallery of Modern Art, including the acquisition and exhibition of contemporary art, continues unabated in an attempt to do justice to the art made from about 1890 to the present day.

ALICE DEWEY
Senior Curator, Scottish National Gallery of Modern Art

new

Darren Almond
Richard Billingham
Henry Bond
Christine Borland
Martin Boyce
Stuart Brisley
Don Brown
Roderick Buchanan
Helen Chadwick
Jake and Dinos Chapman
Alan Charlton
Mat Collishaw
John Coplans
Tony Cragg
Alan Davie
Tacita Dean
Dominic Denis
Kenneth Dingwall
Jacqueline Donachie
Itai Doron
Tracey Emin
Angus Fairhurst
David Faithfull
Ian Hamilton Finlay
Moyna Flannigan
Lucian Freud
Hamish Fulton
Anya Gallaccio
Liam Gillick
Douglas Gordon
Siobhán Hapaska
Andrew Herman
Damien Hirst
Howard Hodgkin
Louise Hopkins
Gary Hume
Callum Innes
Leon Kossoff
Jim Lambie

Michael Landy
Abigail Lane
Langlands and Bell
Sarah Lucas
Chad McCail
Will Maclean
Wendy McMurdo
Nicholas May
Victoria Morton
Julian Opie
Jonathan Owen
Eduardo Paolozzi
Marc Quinn
Carol Rhodes
James Rielly
Deb Rindl
Julie Roberts
Yinka Shonibare
David Shrigley
Paul Simonon
Bob and Roberta Smith
Bridget Smith
Smith / Stewart
Tim Staples
Georgina Starr
Sarah Staton
Kerry Stewart
Marcus Taylor
Sam Taylor-Wood
Graeme Todd
Gavin Turk
Alison Watt
Gillian Wearing
Rachel Whiteread
Max Wigram
Craig Wood
Richard Wright
Cerith Wyn Evans
Catherine Yass

Entries written by
Lucy Askew, Alice Dewey,
Patrick Elliott, Jane Furness,
Keith Hartley, Philip Long,
Fiona Pearson, Ann Simpson
and Logan Sisley

Dimensions are given in
centimetres, height before
width before depth

Richard Billingham
born 1970

Untitled (Mother and Cat), 1995
Illustrated
Fuji longlife colour print,
mounted on aluminium (2/7),
80 × 120
Purchased 1998 · GMA 4222

Untitled (Father and Dog), 1995
Fuji longlife colour print,
mounted on aluminium (5/7),
80 × 120
Purchased 1998 · GMA 4223

Richard Billingham's photographs of his family – initially conceived as aids to portrait painting – brought him rapid renown. His deceptively amateurish images of his alcoholic father, Ray, and obese, tattooed mother, Liz, imprisoned in their tower block, were hailed by critics for their frankness and lack of condescension. Billingham's portrayal of his family circle appeared to expose the experiences of a late twentieth-century underclass in Britain. The photographer revealed their lives as a product of the crumbling social provision of recent decades, separated from the everyday worlds of work and consumption.

However, Billingham's guilelessness has also fuelled controversy. For some, his work contains an implicit social critique, part of a trend in recent British art in which working-class artists have re-emerged to explore otherwise unregarded proletarian subject matter. For others, the photographer can only revel in the degradation he exposes, exploiting his family and pandering to the sensationalist strategies of an art world obsessed by marketing. Billingham has denied any political subtext to the works and insists they are loving portrayals of his family. At the very least his photography requires us to consider the dramatic changes in the way that Britain's working-class has been represented. JF

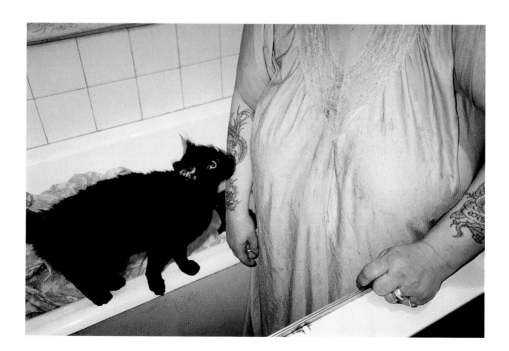

City Park: Strolling, Turning, Kneeling belongs to a continuing series entitled *Velocity of Drops*, which Borland began in 1993. The series was inspired by a display in the Police (Black) Museum in Glasgow in which curiosities linked to crimes are exhibited. The display consisted of drops of blood on pieces of paper. Its label explained how it was possible to measure the drops and so calculate what had caused them. Borland was interested in the construction of an entire scenario from such minimal information. The photographs for the Gallery's *City Park* work were taken by Uwe Walter, in collaboration with Borland, in the Tiergarten in Berlin. They recall the style of police photographers who objectively record a crime scene. The melons in *City Park* are visceral and can easily be related to human flesh. They are also often used in the making of films for shooting practice. As a result the work evokes a crime scene and the viewer is prompted to imagine what has taken place.

Twin, Hand-Birth Demonstration Model relates to Borland's interest in the relationship between art and anatomy and the history of medicine. Borland researched the life and work of William Smellie (1697–1763), a pioneer of obstetrics in Scotland in the eighteenth century. With the curator, Francis McKee, she discovered two hand-made models that Smellie had used in child-birth demonstration lessons (these had lain uncatalogued in the collection of the Royal College of Surgeons, Edinburgh). The models, made from leather, were stuffed with sawdust and contained real foetal skulls. They were tragic, yet had a positive role as teaching aids. Borland wanted to recreate their sense of pathos. She made the Gallery's work using the same methods – including hand-stitching the leather – and the same proportions of the original, but used a plastic foetal skull.

In 1999 Borland collaborated with Dr Douglas Wilcox, Senior Lecturer and Honorary Consultant in the Medical Genetics Department of the University of Glasgow. Borland was interested in Dr Wilcox's work with families affected by congenital conditions, such as Spina Bifida and Duchenne Muscular Distrophy. These conditions can now be identified during routine tests on pregnant women, due to recent advances in de-coding human DNA. The discovery of a disorder inevitably leads to complex ethical issues, including possible termination. Through her discussions with Dr Wilcox, Borland became aware that despite these cutting-edge medical advances, the patient's family tree was fundamental in determining their medical condition – a fact known to nineteenth-

Christine Borland
born 1965

City Park: Strolling, Turning, Kneeling, 1997
Six colour photographs mounted on board, each photograph 25.5 × 25.5, board 84 × 117
From an edition of three plus one artist's proof.
Purchased (Iain Paul Fund)
2000 · GMA 4320

Twin, Hand-Made, Child-Birth Demonstration Model, 1997
Leather, plastic skull, sawdust, 59 × 21 × 7.5
Purchased (Iain Paul Fund)
2000 · GMA 4321

Spirit Collection: Hippocrates, 1999
Detail illustrated
Glass vessels, bleached and preserved leaves of a plane tree (1/2), dimensions variable.
Purchased with assistance from the Knapping Fund and funds from the donations box
2001 · GMA 4391

century doctors. Dr Wilcox also explained that a plane tree, growing in the hospital grounds of Yorkhill Hospital, Glasgow, had been grown from a sapling given by the Greek government and propagated from the tree on the island of Kos under which Hippocrates had taught medicine in the fifth century BC. (The Greek government makes such gifts to medical institutions all over the world.) The Glasgow tree can be understood as a symbol of an international, multigenerational family of medical practitioners, connecting current practice back to its origins.

A few years earlier Borland had examined a spirit collection (botanical material preserved in alcohol and particularly popular with the Victorians)

at the Royal Botanic Garden in Edinburgh. As a result, she had experimented with the 'clearing' technique, a process by which the chlorophyll in leaves is bleached out leaving their vein structure clearly visible. She used this technique to preserve leaves from the Yorkhill plane tree in glass vessels. The one hundred vessels of *Spirit Collection: Hippocrates*, hung from the ceiling, loosely suggest the form of a tree. The use of tinfoil at their necks emerged later when Borland was working with scientists researching abnormalities in cell microcosms at the Wellcome Laboratory in Dundee. She noticed that all sterile glassware was protected with foil to keep out light and dust. Therefore, the foil became shorthand for sterilisation. AD

CHRISTINE BORLAND

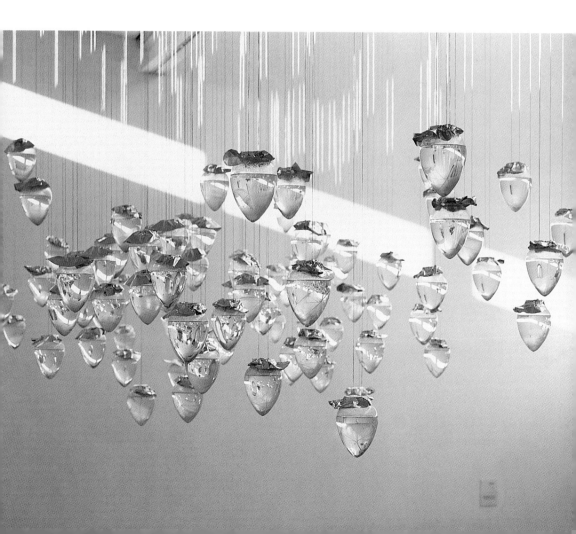

Now I've Got Real Worry (Mask and L-bar) is part of Martin Boyce's development of an imaginary *noir moderne* landscape. This consists of objects of classic design, particularly those by Charles and Ray Eames of the 1940s and 1950s, which have been stripped down to their basic elements, and are used as the basis of a fragmented narrative genre which comments on contemporary life. In this way Boyce compares the ethos in which the objects were made during the post-war boom (using manufacturing techniques developed by the military for mass-production), to the cultural role they now fulfil, based on fashionable taste and monetary value. Boyce also composes short fictional texts describing incidents which occur in *noir moderne* architectural contexts and which include an element of underlying malevolence.

The mask element in *Now I've Got Real Worry (Mask and L-bar)* is made from the top third of a plywood leg splint designed by Charles and Ray Eames and manufactured in 1942–3. They also designed the L-bar as part of the Eames storage units (ESU 400) which were manufactured between 1950 and 1955. Boyce deliberately altered and damaged these items of classic modern design in order to prompt a new kind of debate from the one provoked when they were first manufactured. AD

Martin Boyce
born 1967

Now I've Got Real Worry (Mask and L-bar), 1998–9
Damaged L-bar from ESU 400 storage unit designed in 1950 by Charles and Ray Eames; and altered plywood leg splint designed and manufactured by Charles and Ray Eames in 1942–3 (1/2)
Mask 38 × 19.8 × 7.5
L-bar 148.9 × 1.8 × 1.8
Purchased (Iain Paul Fund)
2001 · GMA 4371

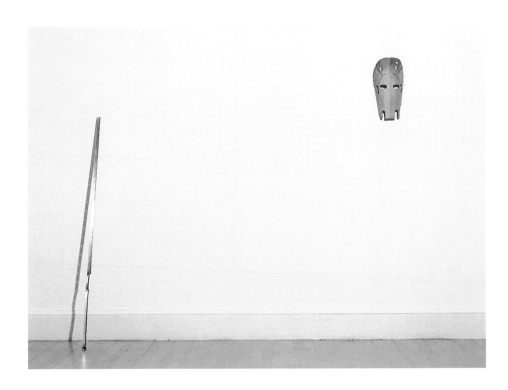

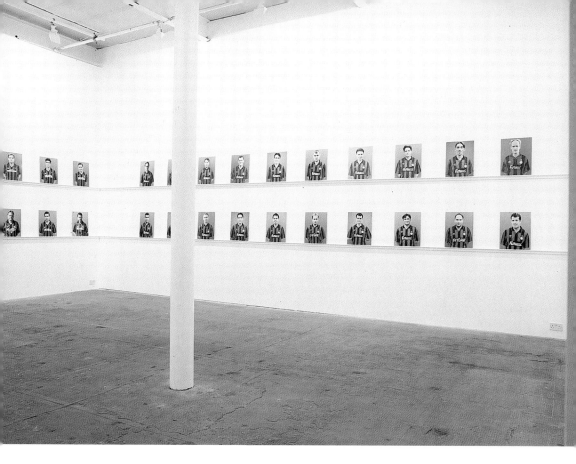

Roderick Buchanan

born 1965

Work in Progress, 1995
Detail illustrated
Thirty-nine photographs,
mounted and laminated onto
rigid PVC, with vinyl lettering,
each photograph 49 × 39
From an edition of two plus one
artist's proof
Purchased (Iain Paul Fund and
Knapping Fund) 2002
GMA 4472

Work in Progress consists of thirty-nine colour photographs, each of which features an individual wearing the team shirt of a Milanese football team. The portraits are reminiscent of football publicity photographs, with the players staring ahead, arms by their sides. While the immediate assumption may be that these are Italian sportsmen, they are, in fact, players from amateur five-a-side Glasgow teams chosen and posed by Buchanan. The photographs are shown alongside a wall text, which reads: 'Players who associate themselves with Italian football by wearing Inter Milan and A.C. Milan shirts amid the dozens of local tops on display every night on the football parks of Glasgow.'

In *Work in Progress*, Buchanan alludes to the aspirations of individuals who, in wearing the strips of top-league professional teams, identify themselves with the abilities of those they admire; Italian football in particular is respected for its skill and style. Buchanan presents us with two teams, rival sides from the same city. This separation into two sets alludes to the need of individuals to give themselves a separate identity, while at the same time maintaining common bonds of knowledge and agreed opinion. PL

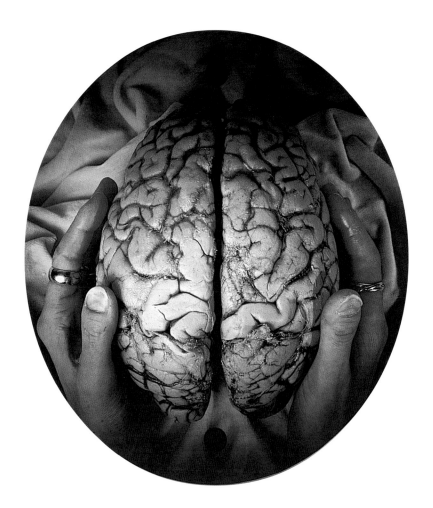

Frequently working with photography, Chadwick used her own body as the subject of her work, often in large-scale installations. In the late 1980s she took her self-portraiture a step further, making a series of exquisite Polaroid photographs of raw meat and offal known as *Meat Abstracts*: sexually provocative, they were suggestive of human flesh. *Self-portrait* comes from the next series, *Meat Lamps*, in which colour transparencies are sand-wiched within glass plates and lit by electric light. It shows the artist's hands gently cradling a disembodied, walnut-like brain. In the same way that, regardless of gender, age or race, everybody's flesh looks the same, so this is true of the brain. It is a portrait of all brains, a kind of collective self-portrait. When we look at the work our brain is effectively looking at itself, a potentially unset-tling experience given that the brain is at the core of our identity. JF

Helen Chadwick
1953–1996

Self-portrait, 1991
Photographic transparency, glass, aluminium frame and electric lights (3/3),
50.9 × 44.6 × 11.8
Gift of the Contemporary Art Society, through a grant from the Henry Moore Foundation
1996 · GMA 4096

Alan Charlton

born 1948

10 Grey Squares, 1991
One illustrated
Portfolio of ten screenprints
(32/35)
Each sheet 58.5 × 58.5
Purchased 1991 · GMA 3623

Charlton began making uniformly grey paintings in 1969. There is no implied metaphorical or spiritual content in the work beyond their existence as grey paintings of varying size and shade. They assert their presence as completely autonomous works, rather than as imitations of anything, or as expressions of anything. Keen to avoid random choice, in 1969 Charlton began basing the size of his works on a 1¾ inch unit – the depth of the painting on its stretcher. He later adopted the 4.5cm metric equivalent. The height and width of his paintings are always divisible by this unit.

The ten squares in this print series are all based on the 4.5cm unit: the smallest square is 9cm, and the size of the other squares increases by 4.5cm, so that they measure 13.5, 18, 22.5 and up to 49.5cm. The paper itself is 58.5cm square, 9cm larger than the largest grey square. All the grey tones are precise duplicates of tones used by Charlton in earlier paintings. The ten prints may be hung in any order. They were produced in an edition of thirty-five sets, plus ten proof sets. PE

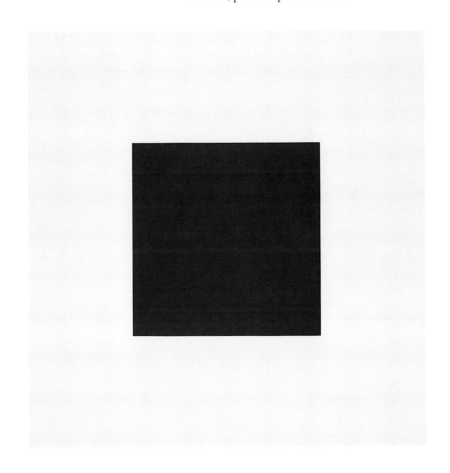

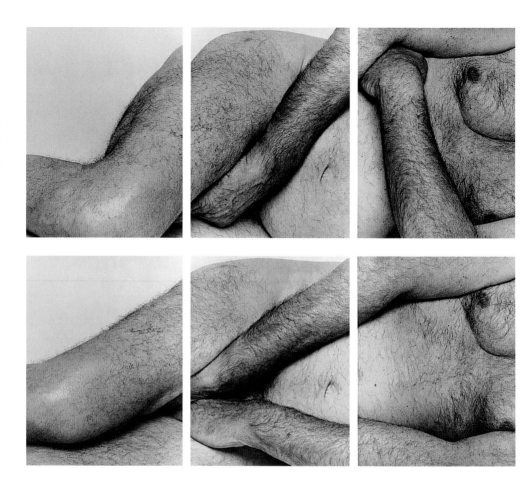

Coplans began taking photographs of his own naked body in 1984, at the age of sixty-four. The photographs are enlarged to giant proportions, and are often presented as multi-part compositions. By excluding his head the image remains general: they are images of every man. They are, moreover, images of a normal, unidealised body. Writing about *Reclining Figure, Two Panels No.1*, Coplans has stated: 'The photograph is a recollection of how pre-civilised mankind (both male and female, young and old) slept: on the ground, near a fire, and who universally covered their genitals and breasts during sleep. We spend a large part of our lives in sleep, it is a continuously shared experience, and as basic to our lives as sex, eating, drinking, and searching for food. This photo is a recollection and reconstruction of this primal act. I have difficulty in recollecting what led me to make this particular photo, but once started I made a series, a common organisational device in the latter part of my work.' PE

John Coplans
born 1920

Reclining Figure, Two Panels No.1, 1996
Black and white photographs: (2/6) two panels each with three-part image, each panel 84 × 191.6
Purchased with the assistance of funds from the donations box 1999 · GMA 4306

Tony Cragg

born 1949

Kolbenneblok, 1989
Bronze, 171 × 237 × 158
Unique cast
Purchased 2000 · GMA 4327

Kolbenneblok comes from a series of voluminous, hollow objects made in plaster or cast in bronze, which Cragg has referred to collectively as the *Early Forms* group. He began producing these in around 1988, at a point in his career when, broadly speaking, his work shifted away from the use of found objects and their arrangement into images, to the use of raw materials such as plaster or bronze, from which to make works. Cragg has said that the *Early Forms* group: 'are always to do with vessels transforming and mutating into one another in space. Vessels are a strong metaphor for the body and organisms of the natural world and in addition, from an archaeological viewpoint, they are the means by which we gauge our own culture and other cultures. *Early Forms* retain their own integrity as revealed by their skin: one can see the real outside surface while it reveals its interior and volumes.' PL

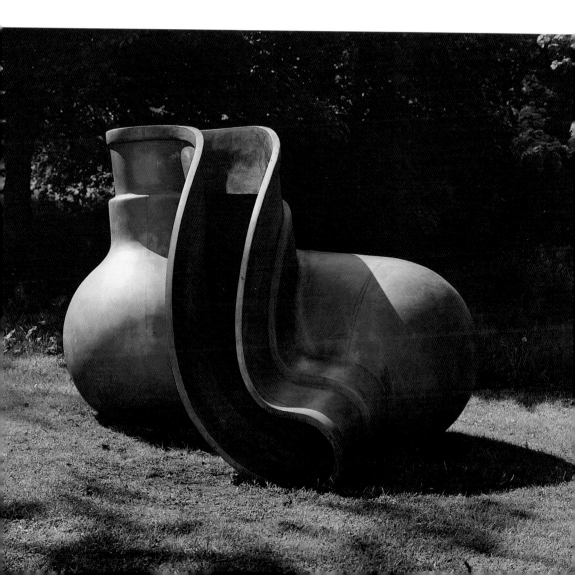

Alan Davie
born 1920

**The Magician's Mirror
No.3 (Opus O.1450)**, 2000
Oil on canvas, 183 × 152
Presented by the artist
2000 · GMA 4326

Davie established his reputation in the 1950s as the European equal of the great American Abstract Expressionists. In the 1960s his brushwork became more controlled and the imagery more legible: mysterious signs and symbols began to appear. In 1975 he acquired a second home on the Caribbean island of St Lucia and this brought about a change in his working pattern: he would make brush drawings there during the winter and in the summer, in England, made paintings, which were developed from the drawings. The initial drawings are always made without a premeditated plan, and while the subsequent gouaches and oils relate to the drawings, they do not follow them exactly. In the 1980s the layering of symbols became more dense: symbols found in sources as varied as American Indian pottery, cosmographic maps, ancient petroglyphs, aboriginal art, Indian miniatures and even phrases from academic textbooks, all found their way into his work, mingling in mysterious and magical ways. Having painted this work, Davie found the central portion reminiscent of a giant convex mirror, hence the title. PE

Kenneth Dingwall
born 1938

Open, 1991
Oil on canvas, 235 × 160
Purchased 1997 · GMA 4173

Commenting on this work, the artist has stated: '*Open* is one of a body of paintings and drawings using this or a variant of the form. The image recurred over a period of years in my sketch and note-books, "marinating", before being developed as a painting. In my mind it grew to represent a balance, with the central axis and rhythms weighing against each other on either side. The colour and tonal pitch were intended to evoke a sense of clarity and light. Alkyd medium was used to build a faceted surface which would catch light as did the angled brush markings. I liked the sense of using my painting to achieve a balance. Thoughts which ran through my head at the time, whether they informed the work or not, were an irritation with an old statement by Frank Stella, "that all European painting did was to balance itself", which seemed to me in the group of works I was doing to be a laudable aim. The other memory is of a Spanish Roman-esque image of souls balanced in a weighing scale.' JF

Emin uses her personal experience to make highly confessional works in which she exposes herself, her hopes, humiliations, failures and successes in a very open manner. Often tragic and frequently humorous, it is as if by telling her story and weaving it into the fiction of her art, she somehow transforms it. The Gallery's works are confrontational and uninhibited and are imbued with a wry sense of humour. They are typical of Emin's direct and simply executed graphic work. To make her monoprints, Emin places a sheet of paper on an inked glass surface and spontaneously scrawls out words and images. Drawing on the back of the paper, the ink transfers (in reverse) onto the front. *Just Remember How It Was* and *A Place for Sleep* were made using calico and are stitched. They relate to Emin's large-scale sewn blankets and other appliquéd work. When seen from a distance these works have a child-like simplicity which appears sweet and innocent, but on closer inspection they are found to express raw emotions and contain uncompromising images. JF

Tracey Emin
born 1963

Just Remember How It Was, 1998
Illustrated
Monoprint on calico with stitching, 34.2 × 41 (irregular)
Purchased 1998 · GMA 4211

A Place for Sleep, 1998
Monoprint on calico with stitching, 27 × 28.3 (irregular)
Purchased 1998 · GMA 4212

Of God and Man, 1997
Monoprint on paper, 42 × 59.3
Purchased 1998 · GMA 4213

Dear Valentine, 1997
Monoprint on paper, 41.9 × 59.2
Purchased 1998 · GMA 4214

I Wanted it in My Face, 1997
Monoprint on paper, 41.9 × 59.5
Purchased 1998 · GMA 4215

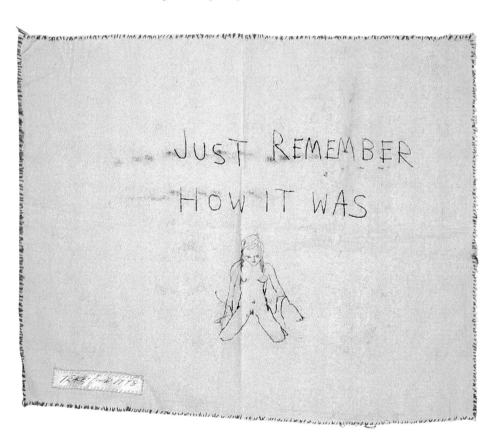

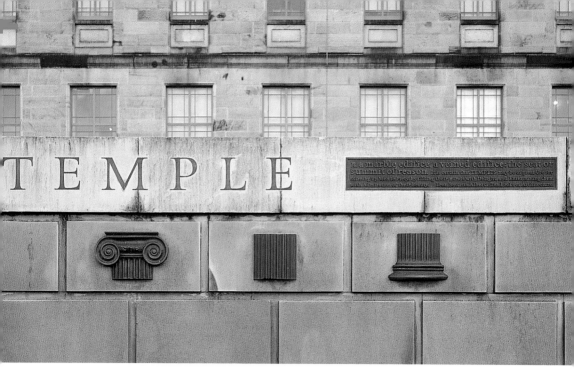

Ian Hamilton Finlay

born 1925

Six Definitions, 2001
(with Andrew Whittle)
Detail illustrated
Series of wall inscriptions, cast
in bronze: *Temple*, 66.6 × 308;
Grove, 17.5 × 276; *Shadow*,
17.5 × 342; *Peace*, 17.5 × 292;
Horizon, 17.5 × 362; *Sheep*,
17.5 × 276
Commissioned and purchased
with assistance from the
National Art Collections Fund
2001 · GMA 4404

After Magritte, 1991
(with Gary Hincks)
Colour lithograph, 62 × 81
Purchased 1993 · GMA A4/0740

**Les Femmes de la Révolution,
After Anselm Kiefer**, 1992
(with Gary Hincks)
Colour lithograph, 69.9 × 81.8
Purchased 1998 · GMA A4/0840

Sackcloth, 1992
(with Pip Hall)
Screenprint, 41.8 × 42.1
Purchased 1993 · GMA A4/0834

While the Gallery of Modern Art has a very large collection of Finlay's printed work, *Six Definitions* is the first sculptural commission undertaken by the artist for the Gallery since 1976. Proposed by Finlay for a specific site in the grounds of the Dean Gallery, the work consists of six separate inscriptions cast in bronze. Each inscription comprises a word cast in large capital letters, followed by a dictionary-type definition and a sentence taken from a literary source. Five of the works have been installed in the bays of a long wall to the north of the Dean Gallery. The sixth, *Temple* (which also features three pictorial elements from an ionic column), is on the other side of the wall, which visitors see as they arrive at the Gallery. It introduces the building as a kind of temple of learning. The other works, *Grove*, *Horizon*, *Sheep*, *Shadow* and *Peace*, which suggest an ideal landscape, face the visitors as they look out across the Gallery grounds. PL

Flannigan is best known for her fictional portraits, based on wry and penetrating observations of contemporary middle-class culture. She has explained: 'My paintings question the objectivity of portrait painting by adopting a more subjective view of representation which involves the creation of an image composed from the imagination.'

Flannigan makes no preparatory work for her paintings: she has an idea of the kind of character she is trying to create and develops this directly on the canvas. Her creative process extends over several months for each work, the end result being one prolonged session of painting, replicating the compression of personalities in each character.

Isobel and *Just Like Daddy* were painted in 1998 on Flannigan's return from a residency in Rome. The influence of Italian Renaissance painting is evident, but *Isobel* is unmistakably a portrait of a contemporary woman. She holds herself bolt upright with her face and large eyes fixed directly on the viewer. At the same time, however, something more subtle is conveyed as she half-turns her pert body away, clasping her hands tightly together.

Unlike the subject of the mother and child, a father and child is very rarely depicted in art. Flannigan plays with the archetype of a madonna and child in *Just Like Daddy* by suggesting a more modern relationship, whilst also exploring the idea of a child in the image of its parents.

Although Flannigan's paintings may contain dry humour they also create a sense of unease. Initially there seems to be an ordinariness about her characters, which makes them believable. However, beyond the veneer of surface appearance lies something else which touches a nerve in those who recognise the types she depicts, or even themselves in the works. AD

Moyna Flannigan
born 1963

Isobel, 1998
Oil on canvas, 55.5 × 60.5
Purchased (Iain Paul Fund) 1999
GMA 4307

Just Like Daddy, 1998
Illustrated
Oil on canvas, 85.2 × 75.1
Purchased (Iain Paul Fund) 1999
GMA 4308

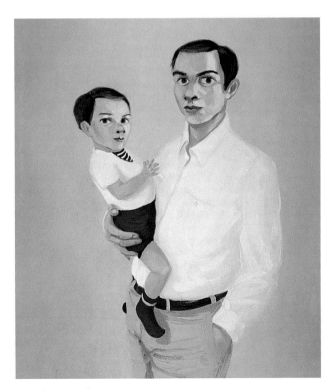

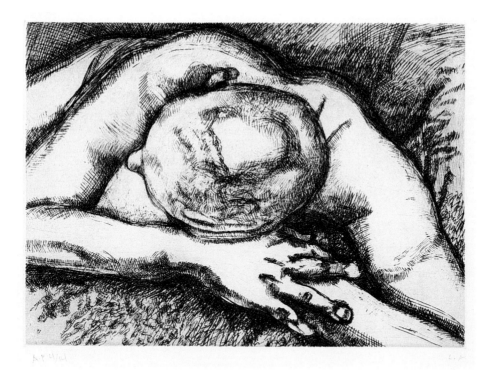

Lucian Freud

born 1922

The Egyptian Book, 1994
Etching on paper (5/12), image:
30 × 30, sheet: 46.3 × 42.5
Purchased with assistance from
the Patrons of the National
Galleries of Scotland 1995
GMA 3881

Reclining Figure, 1994
Illustrated
Etching with drypoint on paper
(4/14), image: 17 × 24.6, sheet:
32.3 × 41.9
Purchased with assistance from
the Patrons of the National
Galleries of Scotland 1995
GMA 3882

Freud produced a few etchings while in Paris in 1946, but
did not take up this technique again until 1982, and has
since made prints regularly. While the closely-controlled
technique in his earliest prints was based on his ability as
a draughtsman, in his more recent work he has utilised
the effects of the etching process to make more expressive
images. Most of Freud's prints are closely related to his
paintings; *The Egyptian Book* corresponds to two paintings
completed by the artist in the early 1990s, which also
feature the book, *Gesichte Ægyptens*, by J.H. Breasted
(published 1936), open at the same page, to reveal plaster
masks of the Amarna period.

The model for *Reclining Figure* was the performance
artist, Leigh Bowery, whom Freud met in 1988. Bowery,
who was physically distinguished by his height and large,
fleshy body, subsequently posed for Freud for several
paintings, drawings and prints. PL

GEESE FLYING SOUTH

NO
THOUGHTS
COUNTING
396
BAREFOOT
PACES
ON
ONE
DEER
PATH

A SEVEN DAY WANDERING WALK CAIRNGORMS SCOTLAND SEPTEMBER 1990

Born of Scottish parents, Fulton has made walks in the Highlands and Islands of Scotland since the early 1970s. He embarked on his first seven-day walk in the Cairngorms in March 1985. By the time *Ten Toes Towards the Rainbow* was published, he had made ten such walks, hence the title of this set of prints. They originated in the small notations Fulton makes while on the walks. The relation between the print and the notes is very direct: even the photographic works are recorded in his notebooks as small sketches with accompanying texts.

The nine works refer to the intense experience of nature, to the idea of the landscape as an active rather than a passive force, and to the qualities of peace and tranquillity found in the wilderness. They also call attention to the gulf that lies between the direct, personal experience of nature and the language one uses to describe that experience. Fulton's work is political in the broadest sense. The Cairngorm mountains, which lie west of Aberdeen, are among the last of the wilderness areas left in Britain and these works are concerned with preserving that status. PE

Hamish Fulton
born 1946

Ten Toes Towards the Rainbow
1993
Geese Flying South illustrated
Portfolio of nine screenprints
(25/35), various sizes between
44.3 × 95.3 and 63 × 96.6
Purchased 1994 · GMA 3825

List of Names (Random) consists of a list of people's names laid out in columns, white on black (or black on white) on a wall or several walls. It looks like a war memorial, but it could equally be a roll of honour. No indication is given as to the identity of those listed or why they are there. In fact, *List of Names (Random)* is a list of all the people that Gordon could remember having met. It was first made for an exhibition, *Self-conscious State*, held at the Third Eye Centre in Glasgow in 1990. On each further occasion, Gordon has added the names of more people whom he has met; but again only those that he could remember.

In 1996 Gordon recalled: 'Around this time I went back to live in Glasgow and one of the first exhibitions I was involved with was *Self-conscious State* at the Third Eye Centre. It seemed important to me that I should try and make something more than the usual kind of smart-ass specific work that was all over the place at that time. In any case, I felt as if I knew too much about the city, or the situation. I couldn't just skim the surface and make some comments and then fly off to somewhere else to do the same thing all over again. So, it was this fact of knowing too much that interested me and I tried to use in the work *List of Names*. The work was trying to examine our system of cognition and memory… So for this work, I tried to remember everyone that I had met and simply displayed all these names in the gallery. There were 1440 names at that time, and the work is ongoing. It functioned quite honestly and as the actual mechanism of memory that most of us use all the time. This meant that on one hand the system was impressively large, and on the other hand it was unbearably oppressive. It was an accurate and honest statement but it was full of mistakes (like forgetting the names of some friends…), so there were some embarrassing elements in the work, but that all seemed to be quite close to the truth of how our head functions anyway. Sometimes it works and sometimes it doesn't.' KH

Douglas Gordon
born 1966

List of Names (Random)
1990–ongoing
Also illustrated on endpapers
Wall text, typeface variable
Purchased (Iain Paul Fund)
2000 · GMA 4335

DOUGLAS GORDON

Hirst began making his spot paintings while still a student at Goldsmiths College, London, in the late 1980s. The spots are nearly always painted the same size and in regular rows with the same distance between them, on canvases of different size and shape. *Spots Car Painting* is Hirst's first collaborative painting, and he has also painted spots on an actual car. This work was painted for the Aids charity, Crusaid. Paul Simonon painted the Citroën car. Simonon was an art student in the mid-1970s before leaving to establish the punk band, The Clash (for which he played bass guitar). Since the demise of The Clash in 1984 he has become a full-time painter.

The abiding theme in Hirst's work is the interface between life and death. Some of his works feature dead animals preserved in fluids while others feature surgical equipment and even cigarette butts. *Love Will Tear Us Apart* is one of a series, begun in 1989, of medicine cabinets containing bottles and packets of drugs. These works refer to our obsession with drugs, which have effectively replaced God in modern mythology. Drugs seem to hold the key to life and death. Hirst remarks that the series is about 'the confidence that drugs will cure everything'. The syringes in this small cabinet are simultaneously threatening and attractive – pastel coloured and packed like sweets in a handy dispenser, yet potentially lethal. A number of Hirst's works are titled after pop songs. The title of this work is taken from a Joy Division record.

Apart from their direct connotations with life and death, Hirst has associated drugs with food. Like food, drugs are normally taken orally and at regular intervals, becoming supplements and even replacements for food. In recent years Hirst has

Damien Hirst
born 1965

Love Will Tear Us Apart, 1995
Plastic cabinet, needles and syringes (19/30),
35.5 × 50.9 × 22.3
Purchased 1998 · GMA 4246

Liver Bacon Onions (from 'The Last Supper'), 1999
Illustrated
Screenprint, 153 × 101.5
An artist's proof from an edition of 150
Presented by Charles Booth-Clibborn, 2001 · GMA 4402

Beautiful C Painting, 1996
Illustrated on back cover
Gloss household paint on canvas, 182.6 diameter
Purchased 2002 · GMA 4477

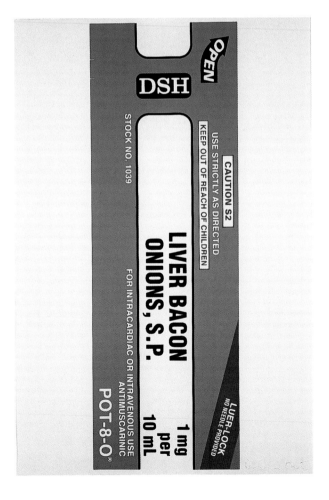

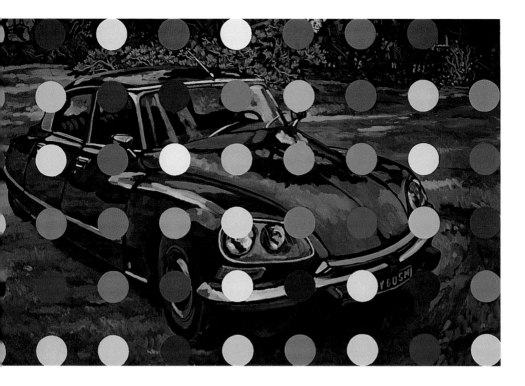

extended his business interests into the world of rest-
aurants. In 1998 he was involved in the opening of a
restaurant called 'Pharmacy' in Notting Hill: the walls are
clad in medicine cabinets full of drug packets.

Referencing the Bible, there are thirteen screenprints
in the *Last Supper* series. The prints are based on specific
pharmaceutical packets (and also pay homage to Warhol's
soup cans). The manufacturers' logos and trademarks
have been changed for Hirst's own name and variant
logos, in apparent allusion to the artist's own status as a
global, marketable product. The drug names have been
displaced by the names of humble foods that might be
found in any corner café in Britain. *Liver Bacon Onions* is
based on a pack of Atropine Sulphate BP Injection. The
injection can be given in the heart or peripheral vein
during a heart attack. A Luer-Lock is a syringe featuring a
lockable needle. The sobriquet Pot–8–0® is a pun on
potato. At Hirst's request, the series was produced in an
edition of 150 sets.

Beautiful C Painting comes from a series of works which
Hirst began in 1995, and which have become known as
'spin paintings'. To create them, he pours paint over a
rotating canvas, a technique he saw demonstrated on *Blue
Peter*, the popular children's television programme. PE

**Damien Hirst
with Paul Simonon**
born 1955

Spots Car Painting, 1998
Illustrated
Oil on canvas, 112.1 × 173.2
Purchased 1998 · GMA 4205

Between 1987 and 1990 Hodgkin executed the oil *In Tangier* (private collection) which incorporated the image of a palm tree, based on his memory of the view from a hotel in the city. *Street Palm* is one of several prints executed by the artist around this time using the same motif. As with many of the artist's prints, *Street Palm* combines printed and hand-applied colours throughout the entire edition. Carborundum is a compound of carbon and silicon, which when applied as a paste to the etching plate leaves an embossed effect on the printed paper. PL

Howard Hodgkin
born 1932

Street Palm, 1990–1
Hand-coloured etching with carborundum (19/55), 149 × 121
Purchased with assistance from the Knapping Fund and funds from the donations box 1998
GMA 4250

This work consists of a map of Europe mounted on board. Acrylic ink has been applied to the areas on the map where water, whether sea, lake or river, is charted, and more land has been simulated in its place. As a result, no water is visible and Europe becomes one continuous landmass, which can be seen on close viewing of the work.

Europe Map (Land) (I) is the first in a series of works Hopkins has made on maps of Europe. They are part of a strand within her oeuvre, using mass-produced maps, which relate to her practice of transforming something familiar into a work of art. She is interested in the change caused by adding just a single layer of paint, making what was once an everyday object into a complicated work. In her map works, Hopkins aims to subvert the readily accepted and biased concepts of how we are told the world looks. By presenting Europe as one landmass in *Europe Map (Land) (I)* Hopkins creates a contradiction of feelings. At first, the work appears familiar to the viewer. However, on closer inspection it is unsettling, as the map is 'not quite right'. Hopkins uses extremely fine brushes and pens and her working process is painstaking, echoing the technique of the original map maker. Yet there is also a casualness and playfulness in her approach. She deliberately employs the same styling as used on the original maps, such as how to indicate deep water, and the use of thick red lines to signify main roads. In this way she further subverts the viewer's preconceptions; used to understanding these established symbols in a certain way, the viewer may be disturbed by Hopkins's sinister yet humorous manipulation of them to re-chart world geography.

AD

Louise Hopkins
born 1965

Europe Map (Land) (1), 1998
Acrylic ink on printed map laid on card, 98.8 × 85
Purchased 1998 · GMA 4207

Detail

Six Identified Forms is one of the earliest paintings in Callum Innes's mature abstract idiom. Innes shares with many artists of his generation a distaste for the idea that artistic meaning derives solely from the artist's intent. Somehow he had to create a situation where it was as much to do with discovery as with creation. It had to feel as if he were 'identifying' pre-existing forms. Innes achieved this by puncturing the paint surface that he himself had applied. The gashes and trails look like random marks inflicted on the canvas, but are in fact very carefully choreographed, using turpentine to remove the paint, coaxing it to run down in closely prescribed courses. The forms that Innes has identified are ambiguous.

In the case of *Exposed Painting: Charcoal Grey / Yellow Oxide / Asphalt* Innes uses a different strategy to objectify the process of painting. He still erases paint with turpentine to create forms, but now they are strictly geometrical rather than irregular and quasi-natural. By reversing the procedure adopted at the beginning, by taking away paint rather than putting it on, and by revealing the various coloured residues of that paint, Innes allows the viewer to participate in the creative process itself. KH

Callum Innes
born 1962

Six Identified Forms, 1992
Illustrated
Oil on canvas, 220 × 190
Purchased (Knapping Fund)
1993 · GMA 3670

Exposed Painting: Charcoal Grey / Yellow Oxide / Asphalt,
1999
Oil on canvas, 227.5 × 222.5
Purchased (Iain Paul Fund) 1999

Leon Kossoff
born 1926

Between Kilburn and Willesden Green, Winter Evening, 1992
Illustrated
Oil on board, 120.5 × 147.5
Purchased with assistance from the National Art Collections Fund, 1994 · GMA 3821

Study for Between Kilburn and Willesden Green, Winter Evening, 1992
Charcoal and oil on paper, 51.8 × 78
Presented by the artist 1995
GMA 3844

Kossoff has been making paintings of railway landscapes in London since the early 1950s and he has also, in recent years, painted railway and underground stations. In the early 1960s he had a studio adjacent to Willesden Junction. These two works show diesel and electric trains passing one another on railway lines running at the foot of the artist's garden in north London. It is an example of Kossoff's urban landscapes, in which racing clouds, swaying trees, hurtling railway carriages and a cold afternoon light, all combine to give an impression of rapid movement. Paradoxically, this image of transience is realised in almost glutinous paint, lending it a tangible and enduring physical presence. The study for the oil is typical of Kossoff's large-scale studies, executed with speed and vigour in charcoal, *in situ*, and later used in the studio as the basis for richly worked oil paintings. Indeed Kossoff refers to the act of painting as 'enriched drawing'. JF

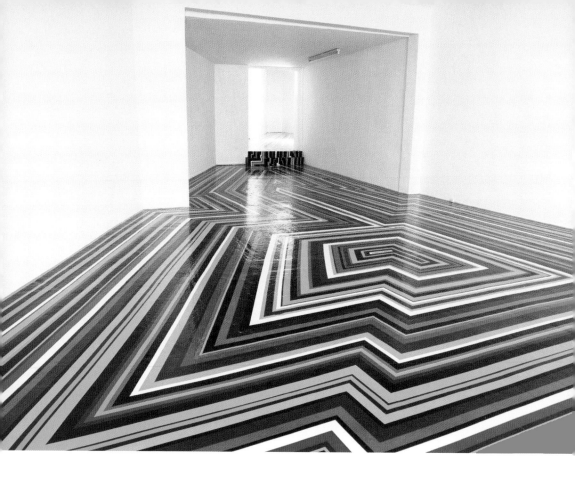

Lambie's first solo exhibition was at Transmission, Glasgow in 1999. He initially thought he would cover the floor with black gaffer tape to create a background for the whole exhibition. While thinking about the kind of work which was being made in the late 1990s Lambie realised that colour seemed to be either over-controlled, or drained away. He, therefore, decided to make something super-coloured, psychedelic even, but which still retained a strong conceptual base. He thought about the space and the structure of the main room at Transmission and decided that he wanted to describe that shape with tape, working inwards from the outer edges. The coloured vinyl tape is used in computer-generated sign-writing, a job which Lambie did before he went to art school. The work is based on the concept of trying to fill a space while still leaving it empty and changes according to where it is installed. It has been compared to the transformation of a space by music (particularly in clubs) and with the colour and rhythm related to the changing moods of musical composition. Lambie has since made versions of *ZOBOP* using black, white and grey tape, multi-coloured metallic tape, and gold, silver, black, and white tape. AD

Jim Lambie
born 1964

ZOBOP, 1999
Installed at The Showroom, London, 2000; also llustrated on front cover.
Vinyl tape, dimensions variable
From an edition of three plus one artist's proof
Purchased 2001 · GMA 4420

Sarah Lucas

born 1962

The Fag Show, 2000
C-print (22/100), 50.5 × 50.5
Presented anonymously 2002
GMA 4468

The Fag Show combines two elements that feature repeatedly in Lucas's work: the self-portrait and the cigarette, although in this case they are referred to obliquely. Lucas is well-known for photographs of herself in which she consciously adopts provocative poses, often with cigarette in hand. In this image her face is obscured by a red balloon with only her hair visible. The words *The Fag Show* are roughly written on the balloon, rendering it a three-dimensional speech bubble. It also recalls bubble gum, blown up so large as to engulf the face. This reference may remind the viewer of the act of respiration and the breathing difficulties many heavy smokers contend with. The masking of the face is a defiant gesture, perhaps against the gaze of the viewer. Lucas held an exhibition of the same title as this work at Sadie Coles HQ, London, in 2000. It included sculptures based on domestic objects covered in cigarettes. Lucas uses cigarettes as she prefers to work with accessible materials and is attracted to them by what she perceives as their sexual connotations. LS

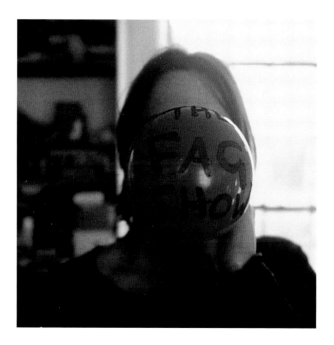

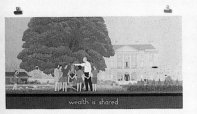
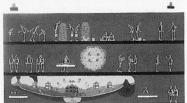
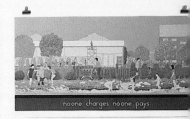

Chad McCail
born 1961

**Wealth is Shared – No One
Charges, No One Pays**, 2000
Gouache on paper, three parts,
each 86.5 × 165.5
Purchased 2000
GMA 4340 A, B, C

CHAD McCAIL

This triptych comes from the series *People Take Turns to Do the Difficult Jobs*, 2000. McCail's main interest is the link between sexual suppression and violence and how they lead to conformity, and how society can be improved by creating a harmonious, sustainable community based on equality. The cartoon-like panels in his work illustrate a core life enjoyed by stick-men and women where sex is not suppressed and there is no violence. In the central image of the Gallery's triptych a man and a woman become friends and have sex. They return to work and the man wants to have sex again, but the woman does not. The man goes to bed and dreams of how a snake poisons relationships between men and women, leading him to understand that men cannot own nor control women. He wakes up and makes friends with the woman. In his pictorial images McCail presents scenes from a life attainable by humans which is an alternative to the ills of contemporary society. In the left-hand image, a wealthy home owner is seen with a group of children burying the key to his house, into which people have moved, as a gesture of abandoning personal property. His garden is being carefully converted to horticultural production while other people are converting cars into something more useful in the background. In the right-hand image, a supermarket has been converted into a large greenhouse so that people can grow peppers, tomatoes and so on. Outside, fruit trees and vegetables are growing where the supermarket car park used to be. The water in the nearby river is clean and children are playing in it.

The optimism of this triptych reflects McCail's desire to evoke the possibility of an improved society. He likens his work to political propaganda and deliberately bases the clear, colourful presentation of his work and the typeface used for the captions on Ladybird educational books for children. AD

Wendy McMurdo

born 1962

Girl with Bears, Royal Museum of Scotland, Edinburgh, 1999
C-Type print on aluminium
(1/5), 120 × 120
Purchased (Iain Paul Fund) 1999
GMA 4310

Solo Violin, St Mary's School, Edinburgh 1998, 1999
Illustrated
Colour negative print on
aluminium (2/5), 120 × 120
Purchased (Iain Paul Fund) 1999
GMA 4311

In 1998 McMurdo was appointed Leverhulme Special Research Fellow at Duncan of Jordanstone College of Art and Design in Dundee. This fellowship allowed her to examine the ways in which technology affected early learning. She subsequently created a new body of work, collaborating with children in a variety of institutional contexts. She worked primarily with schools and within museums and approached St Mary's Music School in Edinburgh, with a view to photographing its pupils during practice sessions. *Solo Violin, St Mary's School, Edinburgh 1998* is one of the images from the resultant *Young Musicians* series. By digitally erasing the girl's violin, the work becomes an image of pure concentration and of absorption in a totally personal space.

From working in schools, McMurdo moved on to observing school pupils visiting museums. The ensuing images developed her interest in the relationship between artefact and viewer, looking at how children animate objects through fantasy and play. In *Girl with Bears*, a young girl observes a dramatic Victorian taxidermy display. Faced with displays like this, children are prompted to deal with difficult issues, such as death and violence, through museum culture. McMurdo took one shot of a whole group looking at the display, and another of just the display, with no on-lookers. Using digital manipulation she was able to isolate one girl, but left several of the children's reflections on the glass. This was partly to invoke the feeling that although children visit museums in groups, their experience is personal and private. The girl's individual engage-ment with the display was the kind of memory that McMurdo had retained from her own childhood school visits to museums. AD

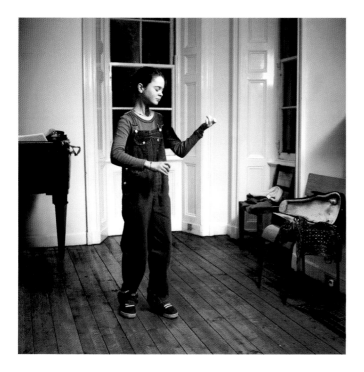

43

Morton began *Dirty Burning* by painting straight onto the unprimed canvas, making numerous tiny paint marks and instinctive gestures layered one over another. The repetitive action of painting a mark over and over again related to the type of electronic music she was listening to at the time. The title was inspired by the 1992 Sonic Youth album, *Dirty*. In *Dirty Burning* Morton pursued the idea of continuous composition in painting, similar to that found in music. The pink area at the right-hand, and the self-portrait in the red/pink area to the lower right of the centre of the painting, relate to the experience of entering the painting and responding psychologically to colour. With *Dirty Burning* Morton wants to provoke a range of profound experiences in the viewer, thus bringing the painting alive and giving it a personality. She wants to create an expanse of space, something mind-expanding which envelopes, even overwhelms the viewer. By painting on a large scale, Morton hopes to make people aware of their bodies in a way similar to the effect of installation art. This approach was inspired by the sound and light installation of LaMonte Young and Marianne Zazeela called *Dreamhouse: Eight Years of Sound and Light*, which Morton visited in New York in 1994. AD

Victoria Morton
born 1971

Dirty Burning, 1997
Oil on canvas, 210 × 180
Purchased (Iain Paul Fund)
2001 · GMA 4369

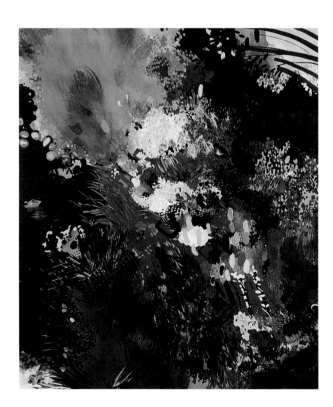

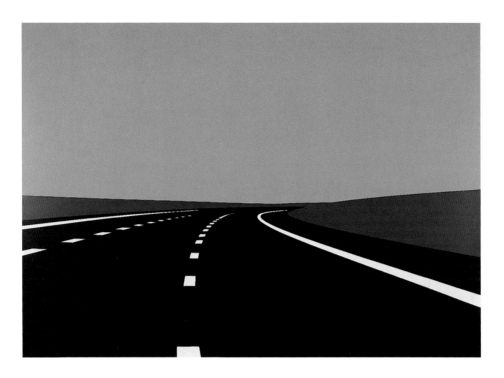

Julian Opie

born 1958

Imagine You Are Driving. 1. 1997
Vinyl stretched on aluminium
frame, 238.8 × 335
Presented by the Contemporary
Art Society 2000 · GMA 4349

Imagine You Are Driving. 1. comes from a chapter in Opie's oeuvre partly inspired by a long road trip which he took across Europe in 1993. Driving became emotionally charged for him and he took photographs along the way. Using the photographs as the basis for paintings, he gradually reduced the amount of detail, until the image was reduced to the white line markings on the road surface, the green verges and the sky. This series of works also relate to Opie's sculptures of the late 1980s, which used illuminated empty frames, images of nowhere and nothing. The Gallery's work comes from a series of four which Opie made in 1997 using the Adobe Illustrator 9 computer programme to make vector drawings, based on the earlier series and stills from an endless animation of the same subject. The drawings were e-mailed to a commercial sign-making company, where they were translated into a programme which directs a computer-guided knife to cut through sheets of coloured vinyl. The pieces of cut vinyl were placed on a plasticated canvas to create the final works. This new technology meant Opie could re-explore the picture's concept on a bigger scale, using purer colour. The method of presentation and the scale of the works recall advertising billboards. Viewers are encouraged mentally and physically to enter the picture, and to imagine themselves on an endless road trip. AD

45

Jonathan Owen graduated from the MFA course at Edinburgh College of Art in 2000. *I Don't Usually Do This*, which featured in his final year exhibition, was awarded the Gallery's John Watson Prize (named after the school building which now houses the Gallery of Modern Art), and was subsequently purchased for the collection. Owen has made several variants of this work, some painted directly onto the wall. The hands were traced from a pornographic magazine. Owen has commented: 'They're specifically male hands and I wanted to arrange them in a way which might perhaps resemble a kind of sign language; so they might read like a text. A lot of my work comes from an uneasiness about the conventions that restrict certain people to certain forms of communication.' PE

Jonathan Owen
born 1973

I Don't Usually Do This, 2000–1
Acrylic on board, 61 × 204.8
Purchased with funds from the
donations box 2001
GMA 4390

Eduardo Paolozzi
born 1924

Daedalus on Wheels, 1991
Bronze, 185 × 51 × 67
From an edition of three
Presented by the artist in
memory of Barbara Grigor, 1994
GMA 3832

Vulcan, 1998–9
Illustrated
Welded steel, 730 high
Commissioned and purchased
with assistance from the
Patrons of the National
Galleries of Scotland 1999
GMA 4285

In 1980 Paolozzi began to teach at the Munich Academy of Fine Arts. The Glyptothek collection of Greek and Roman figurative sculpture was housed nearby. This inspired Paolozzi to return to the human form after a period of abstraction. During the 1980s he made a series of self-portrait figures incorporating machine parts. *Daedalus on Wheels* continues the theme of the robot using geometric forms inspired by computer graphics. Daedalus was the mythical Greek craftsman who made wings to enable his son Icarus to fly. The fists clenching rods suggest the human will to fabricate. The wheeled platform upon which he stands makes Daedalus into one of his own mechanical inventions.

In 1987 Paolozzi made *Self-portrait as Hephaestus* for an office block in London. Hephaestus was the Greek god of the forge and Vulcan is the Roman equivalent. This giant figure of Vulcan was commissioned by Sir Timothy Clifford, the Director-General of the National Galleries of Scotland, after he had seen monumental Buddha statues in Asia. It was also inspired by the double-height space created by architect Terry Farrell at the heart of his conversion of the Dean Orphanage into the National Galleries of Scotland's new Dean Gallery. The figure was made by John Crisfield of The Sculpture Factory, after a model by Paolozzi. It was transported in pieces and welded together on an armature on site. The theme of *Vulcan* is man and machine, which Paolozzi feels is at the heart of the twentieth century. The fact that Vulcan is lame and needs a prop to help him along underlines the vulnerability of men and their creations. A bronze sculpture by Paolozzi, based on *Vulcan*, has been installed near Newcastle railway station. FP

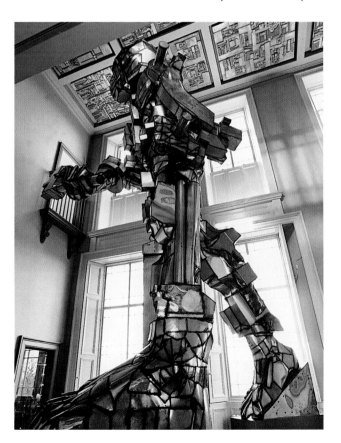

Rhodes is intuitively drawn to areas of landscape which are commonly disregarded, such as areas of scrubland glimpsed through a car window. She is attracted to land which has been manipulated, such as an area covered with tarmac to make a car park, as Rhodes considers it a very human trait to interfere. Her works often have an aerial perspective, making the scenes seem more logical and controllable. She exploits the fine balance between distance as a tool of control and as something frightening. Her source material includes geography textbooks and her own aerial photographs. She begins by tracing detailed preparatory drawings onto specially prepared smooth boards. She paints 'wet on wet', working in long stretches so that the oil paint does not dry before she has finished, wiping down the painting when necessary and starting again, using the white of the board to emphasise the paint surface. She uses muted colours and creates an even light in her pictures, so that when she adds touches of strong colour or shadow they have a greater impact. Rhodes finds the small scale on which she works a pleasing contradiction to the huge space she depicts. AD

Carol Rhodes
born 1959

Car Park, Canal, 1994
Illustrated
Oil on board, 51.4 × 44.6
Purchased 1998 · GMA 4208

Service Station, 1998
Oil on board, 46.9 × 47.1
Purchased 1998 · GMA 4245

James Rielly

born 1956

Hold, 1997
Oil on canvas, 198.2 × 167.6
Purchased 1998 · GMA 4209

Dealing in particular with the theme of childhood and growing up, Rielly's subjects include children with adult heads, identical twins and smiling children with slight deformities. The paintings are a mixture of the funny, the sinister and, often, the sexually provocative. Like most of his paintings, *Hold* is a composite image derived from several photographs. Artificially lit and stiffly composed, it bears the hallmarks of a school portrait photograph, except that there is an ambiguous red mark on the child's forehead. Perhaps a wound, scar, growth or hole, it is emblematic of something wrong yet seems almost proudly displayed, like a badge. A common reaction might be to cover it up, but for Rielly such blemishes may be seen as signs of childhood experience. The title refers to our desire to 'hold' onto memories. The painting concerns the conflict between the passing of time, the desire to pin it down, and the signs of growing up. LS

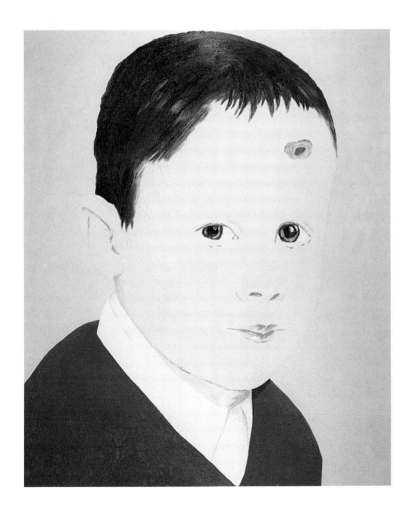

Roberts painted *Shepherdess Marie Antoinette* after visiting Versailles and the hamlet Marie Antoinette had built by the Grand Trianon Lake, between 1783 and 1785, inspired by Jean-Jacques Rousseau's theories about the 'state of nature'. It consisted of twelve buildings including a processing dairy and a barn, which was also used as a ballroom. The main building featured in Roberts's painting is the Queen's House. The French queen took to dressing as a shepherdess, visiting the neighbouring working farm and entertaining in her fairy-tale village, in a style totally at variance to the pomp and ceremony of the court at the Palace of Versailles. Roberts made drawings and photographs on site and once back in her studio created her own impression of the queen in these extraordinary surroundings. Painted in oil with meticulous and tactile realism, the image appears to be floating on the acrylic monochrome background, which enhances the sense of illusion and fantasy. AD

Julie Roberts
born 1963

Shepherdess Marie Antoinette,
1999
Oil and acrylic on canvas,
210 × 180
Purchased 2000 · GMA 4328

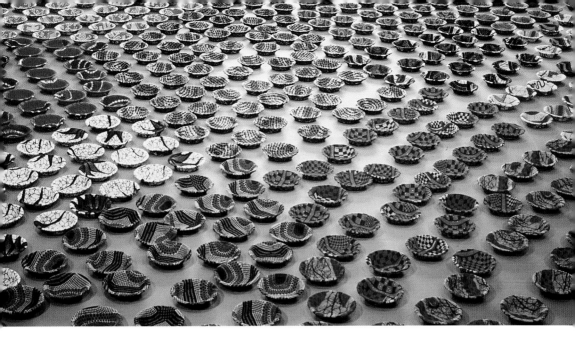

Yinka Shonibare

born 1962

Sun, Sea and Sand, 1995
Detail illustrated
Mixed media installation,
dimensions variable
Purchased with funds from the
donations box 1998 · GMA 4224

Sun, Sea and Sand consists of 1,000 fabric-covered bowls, installed on a blue floor. The fabric is commonly understood to be 'African'. However, the Dutch wax-print or batik technique originated in Indonesia (a Dutch colony until 1949), in the nineteenth century. The technique was industrialised first by the Dutch and then by the British, who export the fabric to West African markets. This kind of fabric became particularly popular there from the 1960s when its bright colours and exuberant designs ironically became associated with post-independence optimism and African nationalism. Shonibare saw the fabric as a perfect metaphor for his own situation – having been brought up in London and Lagos – and he initially used it in place of canvas in paintings.

In the mid-1990s much of the news was dominated by famine in Africa, which contrasted with the contemporaneous presentation of the continent as an exotic holiday destination. On the one hand, the empty bowls in *Sun, Sea and Sand* represent the lack of food and poverty in Africa, whilst on the other their colour and multitude stand for plenty and for luxurious, indulgent foreign holidays. The blue flooring on which the bowls sit refers to the sea. There are several other levels to *Sun, Sea and Sand*: one is based on aesthetics and the idea of repetition and multiples. At the same time the work is not simply about colour and form, but is also about the social significance of the form which is used, such as the meaning of the bowls and what the fabric represents. Thus the work plays with cultural tradition and subverts traditions of modernism, as well as making a political statement. AD

David Shrigley
born 1968

Untitled (Bilious Encounter),
1996
Ink on paper, 21.2 × 29.8
Purchased 1998 · GMA 4225

Untitled (God is in Details), 1997
Ink on black and white
photograph, 19.6 × 29.5
Purchased 1998 · GMA 4227

Untitled (The Super-hero?), 1997
Ink on paper, 21 × 15
Purchased 1998 · GMA 4228

Untitled (Criminal Path), 1997
Ink on paper, 21 × 15
Purchased 1998 · GMA 4229

Untitled (I Go to Sleep), 1997
Ink on cibachrome print,
12.8 × 17.9
Purchased 1998 · GMA 4230

Untitled (The Grabbing Hands),
1997
Ink on paper, 21 × 15
Purchased 1998 · GMA 4231

**Untitled (Black and White Bed
Photo)**, 1997
Ink on black and white
photograph, 10.3 × 15.7
Purchased 1998 · GMA 4232

Untitled (Not Funny), 1997
Ink on paper, 21 × 15
Purchased 1998 · GMA 4233

**Untitled (I am Going to Write to
You…)**, 1996
Ink on paper, 20.6 × 14.7
Purchased 1998 · GMA 4234

Untitled (The Road to Paradise),
1996
Ink on paper, 21 × 15
Purchased 1998 · GMA 4235

Untitled (Enter), 1997
Ink on paper, 21 × 15
Purchased 1998 · GMA 4236

Untitled (While I am Asleep),
1996
Ink on coloured paper, 18 × 14.1
(irregular)
Purchased 1998 · GMA 4237

David Shrigley makes books, drawings, photographs, public interventions and sculpture. His work can be subtly or overtly funny, but the underlying tone is often bleak or deadpan. Soon after he graduated from Glasgow School of Art, he started making books which tread a fine line between comic books and artist books: he found this a cheap and easy way to disseminate his work. He doodles constantly and regards his drawings as the result of spending too much time alone at home. He takes his camera with him almost everywhere, selects certain prints once they have been developed, and sometimes writes on them. His public interventions, such as adding the eyes to the tree in *Fallen Tree with Eyes*, are artworks, which he documents with photographs, which can be displayed in a gallery context. AD

Special Rubbish, 1998
Four cibachrome prints (2/10),
each 20.3 × 25.4
Purchased 1998 · GMA 4238 A–D

Posters for Tram, 1997
Two cibachrome prints (9/10),
A. 15.2 × 20.4; B. 15.2 × 20.3
Purchased 1998 · GMA 4239
A and B

Imagine the Green is Red, 1997
Cibachrome print (5/10),
30.4 × 30.2
Purchased 1998 · GMA 4240

Lost Filofax, 1998
Cibachrome print (7/10),
25.3 × 25.5
Purchased 1998 · GMA 4241

Black Snowman, 1997
Colour photograph (11/12),
15.2 × 20.5
Purchased 1998 · GMA 4242

Fallen Tree with Eyes, 1997
Illustrated
Cibachrome print (12/12),
15.2 × 20.5
Purchased 1998 · GMA 4243

Bridget Smith
born 1966

Neuschwanstein, 1998
C-type photograph on
aluminium, 149.8 × 193.1
Purchased 1998 · GMA 4221

Bridget Smith has commented: 'I always associate a sense of expanse with the idea of escaping, either mentally or physically. Our need to escape and what we escape to has always interested me.' She has worked with these ideas since 1995, making numerous images of man-made environments designed for escapism, most notably cinemas, Las Vegas hotels, and, more recently, Tokyo bars. Unlike these subjects, Neuschwanstein Castle is not a modern construction. However, when it was built in the 1870s, it represented the architectural realisation of one man's dream by fulfilling King Ludwig II of Bavaria's obsession for Germanic medievalism, and providing a fantasy into which he escaped, both mentally and physically, after breaking off his engagement to his cousin Sophie. Smith portrays the castle at night, hiding the mountainous Bavarian landscape in darkness. Illuminated, and floating out of context, Neuschwanstein could be Disneyland's Sleeping Beauty castle, or perhaps just another Las Vegas hotel. Indeed, Smith has noted that: '*Neuschwanstein* came out of a large series of work about Las Vegas. One aspect of Vegas that interested me was the way it would take from any source, but particularly from Europe. Neuschwanstein was the inspiration for the Excalibur hotel/casino [in Las Vegas] and also for Disney's castle. It is the original fairy-tale castle and as such I was interested in photographing it.' LA

Stephanie Smith
born 1968
Edward Stewart
born 1961

Breathing Space, 1997
Double colour DVD projection
installation, with sound (3/3),
dimensions variable
Purchased 1998 · GMA 4195

SMITH / STEWART

Breathing Space comprises two wall-sized image projec-
tions, shown at right angles to each other. The DVDs are
on a sixty-minute loop, which plays continuously. The
projections show two figures from the shoulders up, their
heads covered by plastic bags. We hear the amplified
sound of their constricted breathing, as the plastic is
sucked in and expelled, rustling noisily. The two figures
are separated yet united in their struggle. The bizarre
scene carries associations of torture, violence and sado-
masochism, but it is also visually arresting and full of
black humour. Watching the motionless heads in a dark,
claustrophobic space, we wonder whether this is some
sort of game or punishment – or both. Their complicity in
an action which every child is warned against implies an
element of pleasure in danger but also danger in life, since
breathing is an involuntary necessity. Smith / Stewart's
work deals especially with the notion that pain and
pleasure are interdependent parts of any relationship –
that they perhaps define a relationship. Deliberately
fraught with contradictions, this seemingly vicious work
is about breath – the stuff of life. PE

54

Kerry Stewart

born 1965

Cape, 1996
Fibreglass, resin and cellulose
paint (1/3), 181 × 160 × 128
Purchased 1997 · GMA 4172

'The Only Solution was to…',
1997
Illustrated
Plaster polymer and acrylic
paint (2/3), 55.5 × 70 × 39
Purchased 1998 · GMA 4210

Stewart's subject matter is at once familiar and discon-
certing: a nun lying on the ground, a pregnant schoolgirl,
twin boys in identical clothes, a car trapped in a snowdrift
with its lights still on. Although life-size, her earlier works
have the simplified forms and abrupt colouring associated
with children's toys. *Cape* is just that, a swirling grey cape
with the body of its wearer absent. It is a nightmarish
apparition, an item of clothing conceivably worn by
Darth Vader or Dracula. This sense of menace is height-
ened by the shoulders of the garment which curl over
towards the viewer like grasping hands.

 '*The Only Solution was to …*' presents a small baby in a
carry-cot. The child is asleep in the shiny, leatherette
chair, strapped in by a safety harness. Stumbling across it
on the floor, the viewer is at first inclined to accept it for
the real thing and to look about for the absent parents. On
closer inspection it turns out to be a facsimile. The subject
is commonplace yet unlikely material for an artist. It is
this absence of dramatic or aesthetic potential that makes
the work weird and compelling. The title invites the
viewer to ponder upon what 'the only solution', and
indeed the problem, might have been. LS

Lovecraft is one of several works from 1997–8 in which Todd explores the interface between landscape and monochromatic painting. It was one of the first works he made using a layering technique; starting from a gesso-prepared board he draws and paints using a variety of materials including oil, acrylic ink and pastel. A layer of varnish is applied after each process is completed. Todd responds intuitively at each stage creating a multi-layered painting which is the result of an accumulation of ideas and processes and which yet retains a sense of transparency. Todd cites an eclectic range of influences, from the work of Albrecht Altdorfer, Romanticism and Realism to the idea of the endless plane as found in Surrealism. Todd's work is also reminiscent of Oriental art and, in particular, the Japanese art of lacquering. The concept of form and void in Japanese and Chinese landscape painting, where the space between the forms is as important as the forms themselves, has also influenced his work. Todd intends the saturated red colour of *Lovecraft* to spark the imagination and individual interpretation. The painting appears to be in a state of flux between stillness and movement, depth and flatness, colour and graphic marks. The title is derived from the name of the writer H. P. Lovecraft. AD

Graeme Todd
born 1962

Lovecraft, 1997
Oil, acrylic ink, pastel and
lacquer on board, 106.5 × 122.2
Purchased 1998 · GMA 4206

Alison Watt
born 1965

Sabine, 2000
Oil on canvas, 213.5 × 213.5
Purchased (Knapping Fund)
2001 · GMA 4353

The artist has commented on this work: '*Sabine* is the first of a group of four 'white' paintings (the others are *Rivière*, *Shift* and *Rosebud*) which concluded a series of works entitled *Shift*. Before the creation of *Shift* I had produced images which examined the relationship of the body to that which is used in its support, in particular the way in which objects of dress relate to the human form. My point of reference throughout was the painting of nineteenth-century France, the portraits of women by Ingres most vividly impressing on my consciousness. As I began to focus solely on fabric and its suggestive qualities, the first *Shift* paintings began to emerge. I had found a way of representing the body with the folds and creases created by it. In fabric as with human flesh there is a sense of movement which is perpetual and it is the body and its rhythms which are implicated in *Sabine*. Although the explicit reproduction of the body is lost, it is still echoed within the landscape of the cloth. By severing the fabric from its original narrative you become acutely aware of that which is missing. In *Sabine* I wanted to convey the erotic; the pleasures of seeing and touching as well as the less tangible features of fabric such as scent or even sound. Subjecting the material to an intense scrutiny, translating even the smallest details and yet displacing and altering what I saw created something more than just mere imitation.' AD

Demolished, Whiteread's first print series, originates from a set of twelve of the artist's own photographs of demolition sites, taken between 1993 and 1995. In the same way that Whiteread's negative casts suggest the trace of a human presence, so the tower blocks, with their connotations of social neglect and poverty, are evocative of the countless lives lived within them.

Almost all of Whiteread's sculptures are cast from objects which relate to the human body, such as the space inside wardrobes and baths. *Untitled (Pair)* is cast from an old ceramic mortuary slab. One of the parts presents a lightly hollowed surface, designed to capture bodily fluids and channel them towards the foot end. The second part is a cast of that same concave surface, turned upside down so that it forms a convex shape, this time bordered by a narrow lip which skirts the edge of the form. The pair of sculptures are, so to speak, male and female mortuary slabs which would lock tightly together should one be turned upside-down and placed upon the other. Standing side by side, they are like tombs. Whiteread's first large-scale bronzes, they have been sited in the grounds of the Gallery of Modern Art. PE

Rachel Whiteread
born 1963

Demolished, 1996
Portfolio of twelve screenprints
(4/35), each 48.9 × 74.4
Purchased 1997 · GMA 4201

Untitled (Pair), 1999
Illustrated
Bronze with white cellulose
paint, two parts, each
90 × 77 × 204
From an edition of twelve plus
one artist's proof
Purchased with assistance from
the National Art Collections
Fund 2001 · GMA 4367

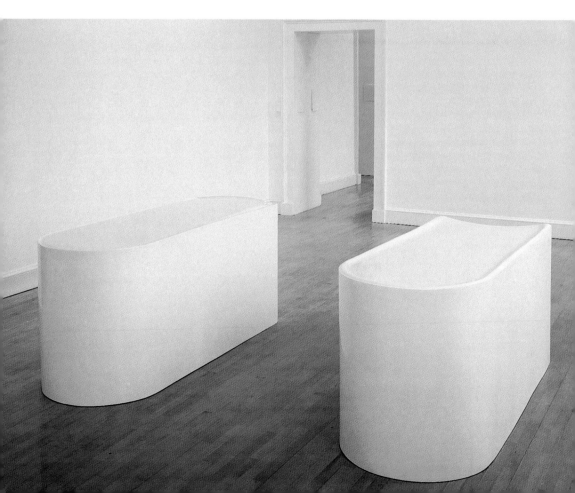

Richard Wright
born 1960

Untitled, 1997
Gouache and Indian ink on
paper, 27.8 × 39
Purchased (Iain Paul Fund)
2001 · GMA 4370

Since the late 1990s Richard Wright has made a number
of drawings on paper, using motifs that relate to some of
his wall paintings. They are not, strictly speaking, studies
but they do allow him to work up ideas that may be used
in some way in the larger paintings. *Untitled* shows two
skulls in three-quarter profile sitting side by side. They
are painted in black gouache with the teeth, eyes and nose
sockets picked out in white. They look identical and could
almost be the same skull seen from both sides. Above
them floats an ornamental shape, part like a leaf, part like
the sign for clubs in a pack of cards. The image is similar
to what one might find on an album cover, club flyer or
tattoo associated with heavy metal rock music or Hell's
Angels. Wright used virtually the same symmetrical
image of skulls in a wall painting he made for *Correspond-
ences: Twelve Artists from Berlin and Scotland*, an exhibition
held in Berlin and Edinburgh in 1997. KH

Robertus Blair and *Annae Craig* are two of five works in the series *Grave*, which Yass photographed in Greyfriars Churchyard, Edinburgh. The series continued Yass's exploration of cultural and historical environments, such as her 1996 light-box series *Corridors*, depicting the interiors of a psychiatric institution. *Grave* was commissioned by the Portfolio Gallery, Edinburgh and was first exhibited at their gallery overlooking the churchyard. Yass sandwiches positive and negative images into a single transparency, disturbing the relationship between light and dark. The sky above the grave is transformed into an eerie, eternal blue, punctuated by white skeletal trees. This haunting of the photograph by its other creates an ambivalent psychic space in which to contemplate our own mortality. The graves themselves are inscribed with memorial texts. That of Annae Craig is screened from the camera by a gate, itself a symbol of the passage to the afterlife. LS

Catherine Yass
born 1963

Grave: Robertus Blair, 1997
Illustrated
Photographic transparency and light box, 89 × 72.5 × 12.5
Purchased 1998 · GMA 4196

Grave: Annae Craig, 1997
Photographic transparency and light box, 89 × 72.5 × 12.5
Purchased 1998 · GMA 4197

London

1992
Portfolio of eleven screenprints
(19/65), various sizes
Purchased 1993

Dominic Denis
born 1963
Untitled
Screenprint, 76 × 82.5 · GMA 3738

Angus Fairhurst
born 1966
When I Woke up in the Morning, the
Feeling was Still There
Screenprint, 86.5 × 65.8 · GMA 3748

Damien Hirst
born 1965
Untitled
Screenprint, 86 × 62.4 · GMA 3739

Michael Landy
born 1963
Cor! What a Bargain!
Screenprint laminated in plastic,
with black marker-pen, 68.5 × 85.7
GMA 3741

Langlands and Bell
Ben Langlands born 1955
Nikki Bell born 1959
UNO City
Blind embossed print, 71 × 74
GMA 3740

Nicholas May
born 1962
Anabatic Print
Screenprint, 88.5 × 60 · GMA 3742

Marc Quinn
born 1964
Template for my Future Plastic Surgery
Screenprint, 86 × 68 · GMA 3743

Marcus Taylor
born 1964
Untitled
Screenprint, 86 × 70.5 · GMA 3744

Gavin Turk
born 1967
Gavin Turk Right Hand and Forearm
Illustrated
Screenprint, 86 × 68 · GMA 3745

Rachel Whiteread
born 1963
Mausoleum under Construction
(after a photograph by Camilo José
Vergara)
Screenprint, 71 × 88 · GMA 3746

Craig Wood
born 1960
Safeway Gel Air Freshener, Alpine
Garden (Detail)
Screenprint with mould-cut sections,
66 × 86 · GMA 3747

Published by The Paragon Press, this portfolio features work by eleven young artists who were, at the time of publication in 1992, based in London and beginning to gain international recognition. Denis, Fairhurst, Hirst, Landy and Wood had all studied at Goldsmiths College, London, in the late 1980s; Hirst had been one of the organisers of a group of exhibitions (*Freeze, Gambler,* and *Modern Medicine*) held in London between 1988 and 1990, which included work by himself, Fairhurst, Denis and Wood. Quinn, Turk, Hirst and Taylor had all featured in exhibitions organised by Jay Jopling (who later opened White Cube in London); and Landy, Fairhurst and Whiteread had all shown at Karsten Schubert Ltd in London. Work by Hirst, Whiteread and Langlands and Bell had also attracted much interest when shown at the Saatchi Gallery, London, in 1992. Craig Wood had shown with the Laure Genillard Gallery in London, and Langlands and Bell had shown with Maureen Paley and Glenn Scott-Wright, also in London. Thus as well as representing the work of young London artists, the portfolio also showcased the young London art dealers.

Few of the artists had done any printmaking before embarking upon this project. The only restrictions imposed upon them were that the printed image should be two-dimensional and that it should be no larger than 30 × 35 inches (76 × 89). All the prints were made between February and May 1992. PE

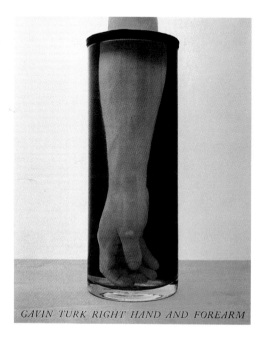

GAVIN TURK RIGHT HAND AND FOREARM

Other Men's Flowers

1994
Portfolio of fifteen prints in
letterpress and screenprint (25/
100), each 47 × 61 or 61 × 47
Presented by Charles Booth-
Clibborn in memory of Joshua
Compston 1996

All prints are untitled

Henry Bond
born 1966
Letterpress, 61 × 47 · GMA 3876 E

Stuart Brisley
born 1933
Letterpress, 61 × 47 · GMA 3876 F

Don Brown
born 1962
Letterpress, 61 × 47 · GMA 3876 G

Helen Chadwick
born 1953
Letterpress, 61 × 47 · GMA 3876 H

Mat Collishaw
born 1966
Letterpress, 61 × 47 · GMA 3876 I

Itai Doron
born 1967
Letterpress, 61 × 47 · GMA 3876 J

Tracey Emin
born 1963
Letterpress, 61 × 47 · GMA 3876 K

Angus Fairhurst
born 1966
Letterpress, 47 × 61 · GMA 3876 L

Liam Gillick
born 1964
Letterpress, 47 × 61 · GMA 3876 M

Andrew Herman
born 1961
Illustrated
Letterpress, 61 × 47 · GMA 3876 N

Gary Hume
born 1962
Screenprint, 61 × 47 · GMA 3876 O

Sarah Staton
born 1961
Letterpress, 61 × 47 · GMA 3876 P

Sam Taylor-Wood
born 1967
Letterpress, 47 × 61 · GMA 3876 Q

Gavin Turk
born 1967
Screenprint, 47 × 61 · GMA 3876 R

Max Wigram
born 1966
Screenprint and letterpress, 47 × 61 ·
GMA 3876 S

The fifteen artists who contributed to this portfolio were
each invited to make prints of a specific dimension
(47 × 61 or 61 × 47), and to make work based exclusively
on text, not pictorial images. The artists were selected by
Joshua Compston, who ran the gallery, Factual Nonsense,
in Charlotte Road, London, from 1992 until his premature
death in 1996. Book and portfolio editions were pub-
lished, the former in an edition of fifty, with twenty
artists' proof copies, the latter in an edition of 100 with
twenty artists' copies. It was published by Charles Booth-
Clibborn of The Paragon Press, who presented this copy
to the Gallery in memory of Joshua Compston. PE

Screen

1997
Portfolio of eleven screenprints
of various sizes (12/75)
Purchased 1998

Darren Almond
born 1971
Multiple Working
Screenprint, 73 × 88.9 · GMA 4200 A

Jake and Dinos Chapman
Jake Chapman born 1962,
Dinos Chapman born 1966
Double Deathshead
Screenprint with phosphorescent
ink, and applied plastic eyes on
springs, 73.4 × 88.9 · GMA 4200 B

Mat Collishaw
born 1966
Untitled
Screenprint on Melinex polyester
board, 85.9 × 57.2 · GMA 4200 C

Anya Gallaccio
born 1963
Broken English August '91
Screenprint, 68 × 88.5 · GMA 4200 D

Siobhán Hapaska
born 1963
Untitled
Screenprint, 57.8 × 89 · GMA 4200 E

Abigail Lane
born 1967
Dinomouse Sequel Mutant X
Screenprint, 56.8 × 88.3 · GMA 4200 F

Georgina Starr
born 1968
You Stole My Look!
Illustrated
Screenprint, 88.8 × 72 · GMA 4200 G

Sam Taylor-Wood
born 1967
Red Snow
Screenprint, 74.9 × 88.4 · GMA 4200 H

Gillian Wearing
born 1963
The Garden
Screenprint, 60.6 × 88.9 · GMA 4200 I

Cerith Wyn Evans
born 1958
The Return of the Return of the
Durutti Column
Screenprint with phosphorescent
ink, 74 × 87.8 · GMA 4200 J

Catherine Yass
born 1963
Stage
Screenprint, 88.8 × 74 · GMA 4200 K

Like the group portfolio *London*, this portfolio of prints
was published by The Paragon Press. *Screen* also includes
work by a young generation of London-based artists,
most of whom were born in the 1960s. The project had
the same format as the *London* portfolio: apart from the
requirement to make a screenprint, the only limitation
was to make a work less than 76 × 89 (30 × 35 inches) in
size. The title *Screen* refers to the screenprint technique
but also references the fact that most of the artists had
worked with video or photography. Once more, the
concept was to create a kind of portable exhibition which
would showcase the work of this younger generation, and
the artists were encouraged to make prints which typified
their current concerns. The prints were made between
February and July 1997. PE

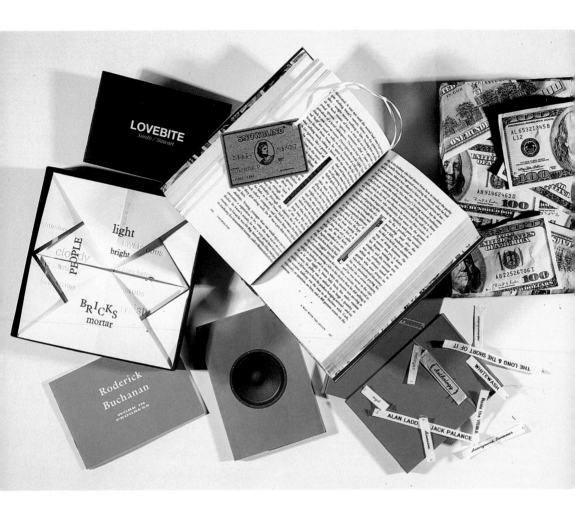

Clockwise from top left:

Smith / Stewart
Lovebite, 1995

Damien Hirst, Robert Sabbag and Howard Marks
Snowblind: A Brief Career in the Cocaine Trade, 1998

Morning Star Press
Anthology, 1997

Jacqueline Donachie
Part Edit, 1994

Roderick Buchanan
Work in Progress, 1995

Deb Rindl
Parallel Lives, 1995

Since opening in 1960, the Scottish National Gallery of Modern Art has formed a Special Books Collection, which documents the developing role of artists in book-making throughout the twentieth century and up to the present day. The collection now consists of over 3,500 titles with a particularly strong holding of dada and surrealist books. There are also over 1,400 artist books, works that have been published since 1960, including a substantial holding of the printed works of Ian Hamilton Finlay. Each year we extend the collection by purchasing items which are lacking from the historical collection as well as acquiring cutting-edge books by contemporary artists. The collection is housed in the Dean Gallery and is displayed in the specially designed Gabrielle Keiller Library.

During the twentieth century, artists moved away from a purely illustrative role in book production to create books that can be viewed as works of art in their own right. In the early years of the twentieth century, avant-garde book artists, the Dadaists in particular, broke with conventions of lettering and textual space. Surrealists continued this practice, focusing on dream-like juxtapositions of image and word. Since then, artists have continued to engage in the process of producing work that seeks to challenge our perceptions of the form. These are so many and varied that a precise definition of the term 'artist book' is hard to achieve. The books may seem familiar, they often have a sequence of pages bound together at the spine, but the artist may actively seek to disrupt our habitual ways of seeing and reading.

These complicated variations that can mix traditional craftsmanship and new technology range from inexpensively produced multiples to expensive, limited editions, and signed *livres d'artiste* such as Hamish Fulton's *A Twelve Day Walk and Eighty Four Paces*, London, 1991. Its visual forms include concrete poetry, in which a single word and the space around it have equal significance. Pop art, conceptual art, photography, painting, architecture, the craft elements of typography, binding and paper-making are all part of the vocabulary.

Elements taken from children's book design opened up new areas for book artists. For example, Damien Hirst used pop-up and pull-out elements in *I want to spend the rest of my life everywhere, with everyone, one to one, always, forever, now*, London, 1997. David Shrigley's books relate to comic book and cartoon formats, while Julian Opie and Marion Ackermann's *Daniel – Yes; Christine – No*, Munich, 1999, takes the form of a flip-book.

The influence of Japanese paper folding can be seen in books that abandon a traditional page-turning format to take on a three-dimensional aspect. For instance, Deb Rindl, who describes herself as a book-sculptor, produces works in which text is incorporated into the most complex three-dimensional folded paper forms such as *Parallel Lives*, London, 1995. Some bookworks may be regarded as sculpture before they are looked on as books, as with Tim Staples's *Under Pressure*, Bristol, 1994.

Sometimes an artist may make an intervention to an existing book, enhancing or even overwriting its meaning. In *Snowblind*, Damien Hirst takes Robert Sabbag's book of that name of 1976 and repackages it in a mirror-glass binding with a dollar bill and credit card intervention in the text block.

Exhibition catalogues can qualify as artist books; for example Tacita Dean's *Teignmouth Electron*, 1999, was the catalogue of an exhibition at the National Maritime Museum, London, while Catherine Yass's *Star* accompanied a British Council exhibition of 2001.

Electronic innovations, computerised typography and graphics have extended the range for artists. Fine editions have now become available in multiple copies to a much wider audience. But perhaps the most crucial element of the artist book is the very intimate relationship the reader has with the object. He or she can interact with the book to transform it or modify it, to create different experiences. In books, text and images tend to be considered separately, with an artist book the experience is simultaneous, the whole being greater than the sum of its parts.

The book is one of the most easily accessible and portable of art forms and sets up an intimate dialogue with the reader. To engage with such a work is to take part in something akin to a happening. The artist book is quite at home in the post-modern world of performance art, sound-works and installations. According to René Hubert: 'Avant-garde artistry has invaded the world of books.'

ANN SIMPSON
Senior Curator, Archive and Library,
Scottish National Gallery of Modern Art

Roderick Buchanan

born 1965

Work in Progress

Glasgow, Tramway, 1995
Purchased 1997
GMA A33/AB 0496
Edition of 500; 16pp.; ill.; pbk
with cover as part of work;
12.5 × 14.8

Published to coincide with a
presentation of *Work in Progress*
by Buchanan in the Project
Room at Tramway, Glasgow,
21 January – 26 February 1995.

Tacita Dean

born 1965

**Teignmouth Electron:
Tacita Dean**

London, Bookworks in
association with the National
Maritime Museum, London,
1999
Purchased 2000
GMA A33/AB 0589
74pp.; ill.; hbk with wrapper;
24.8 × 19
Published to accompany an
exhibition at the National
Maritime Museum, London
1999.

Jacqueline Donachie

born 1969

**3,532 Miles
17th – 29th August 1996**

Glasgow, The Armpit Press,
1997
Purchased 2000
GMA A33/AB 0488
Edition of 1,000; iv, 128pp., iv;
ill.; pbk with ill. wrapper;
14.4 × 10

3,532 Miles, designed and
produced by Jacqueline
Donachie, was made following a
road trip from New York to
New Orleans, via Graceland in
August, 1996.

Part Edit

Glasgow, Tramway, 1994
Purchased 1997
GMA A33/AB 0495
Edition of 500; iv, 76pp., iv; ill.;
pbk with wrapper; 15 × 10.5

Published to coincide with the
exhibition *Part Edit* held at the
Tramway, June – July 1994

David Faithfull

born 1961

Edit/Tide

Edinburgh, Semper Fidelis, 1997
Purchased 1997
2 copies: GMA A33/AB 0579
GMA A33/AB 0580
Edition of 400; 32pp.; ill., with
black and white photographs
taken on the Ross of Mull of the
remains of the Argosy; pbk with
white cover lined in brown
(copy 1) and brown cover lined
in white (copy 2); 14.6 × 10.5

Published to accompany an
exhibition of palindromic and
associated works by David
Faithfull held at Ruggero Toni
Gallery, Parco Mignola,
Malcesine, Italy.

Ian Hamilton Finlay

born 1925

**Les Femmes de la Révolution:
After Anselm Kiefer**

with Gary Hincks
Little Sparta, Wild Hawthorn
Press, 1992
Purchased 1992
GMA A4/0808
Card; 20.1 × 15.9

Western Approaches

Little Sparta, Wild Hawthorn
Press, 1992
Purchased 1992
GMA A4/0784
Folding card; 10 × 21 (42 open)

**Five Finials
'nature is upheld by
antagonism' – Emerson**

with Andrew Townsend
Little Sparta, Wild Hawthorn
Press, 1992
Purchased 1992 · GMA A4/0818
Concertina card; 14.8 × 7.33

A Dream is Always a Sentiment of a Truth
with Curwin Kerstin (photography)
Little Sparta, Wild Hawthorn
Press, 1993
Purchased 1993
GMA A4/0767
Card; 15.5 × 10.5

Blue/Lark
Little Sparta, Wild Hawthorn
Press, 1993
Purchased 1993
GMA A4/0774
Card; 17.4 × 10

Clouds/Rain
Little Sparta, Wild Hawthorn
Press, 1993
Purchased 1993
GMA A4/0775
Card; 17.4 × 9.9

Spring Verses
with Mark Stewart
Little Sparta, Wild Hawthorn
Press, 1993
Purchased 1993
GMA A4/0753
Booklet; 16pp.; 7.9 × 15.5

**Saint Sebastian
Martyred by liberals making 'points'**
with Gary Hincks (after Jan
Sanders van Hemessen)
Little Sparta, Wild Hawthorn
Press, 1994
Purchased 1994
GMA A4/0913
Card; 9.1 × 15.5; for Tom
Lubbock

**Cours après moi que
je t'attrape
CH.8619
Translation: Flirt**
Little Sparta, Wild Hawthorn
Press, 1994
Purchased 1994
GMA A4/0924
Card; 9.3 × 14.5

Creels and Creels
Little Sparta, Wild Hawthorn
Press, 1994
Purchased 1994
GMA A4/0902
Card; 8.3 × 12.1

Citron Bleu
with Gary Hincks (after a detail
in a painting by William Gillies)
Little Sparta, Wild Hawthorn
Press, 1994
Purchased 1994
GMA A4/0874
Card; 11.7 × 15.9

Im dunkelen Laub…
with Pia Maria Simig
Little Sparta, Wild Hawthorn
Press, 1994
Purchased 1994
GMA A4/0872
Card; 11.7 × 13.6

**Foxglove
Digitalis purpurea**
Little Sparta, Wild Hawthorn
Press, 1994
Purchased 1994
GMA A4/0904
Folding card; 5.7 × 10.5

Streiflichter
with Annet Stirling and
Pia Maria Simig
Little Sparta, Wild Hawthorn
Press, 1994
Purchased 1994
GMA A4/0869
Catalogue; 28pp; ill.; 10.7 × 13.3

Evolution
Little Sparta, Wild Hawthorn
Press, 1994
Purchased 1994
GMA A4/0898
Concertina card in folder; 6 × 6

Four Trees
with Ron Costley
Little Sparta, Wild Hawthorn
Press, 1994
Purchased 1994
GMA A4/0884
Booklet and bookmark; 14pp.
10.1 × 6.3

Translation
Little Sparta, Wild Hawthorn
Press, 1994
Purchased 1994
GMA A4/0899
Folding card; 5 × 5.5

Hamish Fulton
born 1946

**A Twelve Day Walk and Eighty
Four Paces**
London, The Paragon Press,
1991
Presented by Charles Booth-
Clibborn, 1995
GMA A33/AB 0600
No.22 of an edition of 35,
numbered 1 to 35 plus 10 proof
copies; [36]pp.; ill. with 16
double-page spreads, 2 colour;
hbk, black cloth binding with
blind-embossed skyline on
front and moon on reverse
designed by the artist, made by
Gray's Bookbinder, London;
signed and numbered by the
artist on colophon page; 32 × 56.

The book presents two
journeys. The pages on the left
refer to twelve mountain passes
in Ladakh, northern India; and
the pages on the right to an area
within a one mile radius of
Fulton's home near Canterbury
in Kent. The twelve-day
walking journey in northern
India, made in July 1984, took
Fulton across twelve high
mountain passes between
Lamayura and Dras. The twelve
walks in Kent were each seven
paces long and were made
between May 1988 and July
1990.

Douglas Gordon
born 1966

**Feature Film: a book by
Douglas Gordon**
with Raymond Bellour and
Royal S. Brown
London, Afterlives/Bookworks;
Galerie du jour – agnès b, 1999
Purchased 2001
GMA A33/AB 0588
200pp.; ill.; pbk; cover contains
inset CDROM of film; with 8pp.
insert consisting of the text of
two essays; 19 × 24

Feature Film was published to coincide with the release of Douglas Gordon's *Feature Film* with James Conlon, filmed and recorded in the studios of Radio France, Paris, 1998, as the Artangel/Becks Commission 1998 and the Central Art Award 1998.

Damien Hirst
born 1965

I want to spend the rest of my life everywhere, with everyone, one to one, always, forever, now
edited by Robert Violette
London, Booth-Clibborn Editions, 1997
Purchased 1998
GMA A33/AB 0575
334pp.; ill. includes cut-out, fold-out and pop up elements; hbk with wrapper; 33.5 × 29.5

Designed by Jonathan Barnbrook with the artist's collaboration.

Snowblind: A Brief Career in the Cocaine Trade
by Robert Sabbag with an introduction by Howard Marks
Edinburgh, Rebel Press, 1998
Purchased 2001
GMA A33/AB 0569
No.21 of an edition of 1,000 special copies designed by Damien Hirst, of a book by Robert Sabbag, first published in 1976; 304pp.; hbk; 22.3 × 13.1

The book has a US dollar bill set into a cut between pp.85–212; metal bookmark representing American Express credit card between pp.84–5; bound in mirror-glass with endpapers illus. US dollar bills; in slipcase covered with same paper as endpapers.

Callum Innes
born 1962

Evidence. Folio
with poems by John Burnside
Edinburgh, Morning Star Publications and Eindhoven, Peninsula, 1996
Purchased 1996
GMA A33/AB 0494
No.71 of an edition of 250; loose-leaf folio containing: 4pp. folded sheet with print signed by the artist; 12pp. text with col. ill. folded paper cover; all in card cover with col. ill.;
21 × 14.3

Folio is a companion publication to a portfolio of the same name. It contains three watercolours printed in offset chosen from a series of fifty watercolours made by the artist during May 1996 and a previously unpublished prose poem by John Burnside.

exposed paintings
Edinburgh, Callum Innes and the Ingleby Gallery, 2001
Purchased 2002
GMA A33/AB 0576
No.10 of 50 special copies, signed and numbered with an original work by the artist, of an edition of 1,000; 108pp.; ill.; hbk with wrapper; 21.4 × 16.8; pp.6–7 has original oil painting on paper by Innes.

Will Maclean
born 1941

St Kilda Waulking Song
with Valerie Gillies and William Gillies
Edinburgh and Inverness, Morning Star Press and art.tm, 1998
Purchased 1998
GMA A33/AB 0476
Unnumbered copy of an edition of 400; 32pp.; ill.; pbk;
10.5 × 14.8

Morning Star Press

Anthology
Edinburgh, Morning Star Press, 1997
Purchased 1998
GMA A33/AB 0478
Edition of 200; [24]pp.; ill., text is image; hbk in slipcase with Cash's name tape on front;
14.2 × 10.4

Enclosed is a glasine envelope containing 21 Cash's name tapes. Contributors include Harry Gilonis, Ian Hamilton Finlay, Jackson MacLow and Ian Stephen.

Julian Opie
born 1958

Daniel – Yes; Christine – No
with Marion Ackermann
Munich, Städtische Galerie im Lenbachhaus, 1999
Purchased 2000
GMA A33/AB 0581
Flip book; ii, 80pp., ii; ill.; hbk;
10.4 × 14.6

Published to accompany an exhibition at the Städtische Galerie im Lenbachhaus, Munich, 16 October – 28 November 1999.

Deb Rindl
born 1956

Parallel Lives
London, Deb Rindl, 1995
Purchased 1996
GMA 33/AB 0558
Edition of 20; folded paper book in box; 19 × 19

Book printed in blue and grey onto cream paper, cut and folded in origami style, supported on a base of hand-made black paper with compressed gold and silver flakes, folded concertina style, inside black paper-covered box.

David Shrigley

born 1968

Err

London, David Shrigley and
Bookworks, 1996
Purchased 1997
GMA A33/AB 0490
Edition of 1,000; 100pp.; ill.;
pbk; 21 × 15

To make meringue you must beat the egg whites until they look like this

Copenhagen, Galleri Nicolai
Wallner, 1998
Purchased 2000
GMA A33/AB 0567
80pp.; ill.; pbk; 24 × 21

The Beast is Near

London, Redstone Press, 1999
Purchased 2000
GMA A33/AB 0572
48pp.; ill.; pbk with wrap-round
cover; 20 × 13

The book has an extra tuck-in
flap to send it by post.

Grip

Edinburgh, Pocketbooks, 2000
Purchased 2000
GMA A33/AB 0571
208pp.; ill. incl. 16 colour; pbk
with wrap-round cover;
17 × 12.6

The drawings reproduced form
a day book for the new
millennium. No.7 in the
Pocketbooks series.

Bob and Roberta Smith

Patrick Brill born 1962

A is for Book: a colouring in book

London, mr & mrs design
(iMMprint), 2001
Purchased 2002
GMA A33/AB 0582
i., 32pp., i.; ill.; hbk, with ill.
cover; 21.5 × 21.5

Smith / Stewart

Stephanie Smith born 1968 /
Edward Stewart born 1961

Lovebite: Smith / Stewart

Glasgow, Tramway, 1995
Purchased 1995
GMA A33/AB 0493
Edition of 500; 24pp.; ill. with
colour photographs; pbk;
10 × 14.8

Published to coincide with the
presentation of video installa-
tions by Smith / Stewart for the
Project Room and Sound Lobby,
at Tramway, Glasgow, Septem-
ber 1995.

Tim Staples

born 1956

Under Pressure

Bristol, Tim Staples, 1994
Purchased 1996
GMA A33/AB 0556
Copy 7B of an edition of 11;
each is unique, made to order;
19 sheets of paper and inset
tissue paper; ill. with two prints
taken from a washer, the centre
sheet has the washer inset;
16 × 16; the leaves are pressed
between MDF blocks and held
by washers and nuts similar to a
flower press.

Catherine Yass

born 1963

Star

with text by Vikram Chandra
London, British Council, 2001
GMA AB 0581
Purchased 2001
32pp.; ill. with colour photo-
graphs by Yass; hbk, with
purple/blue shot silk cover;
13.4 × 20.3
Published to coincide with
Britain's participation in the
10th Indian Triennale,
New Delhi.

Entries compiled by
Lucy Askew, Alice Dewey,
Patrick Elliott, Jane Furness,
Keith Hartley, Philip Long,
Fiona Pearson, Ann Simpson
and Logan Sisley

Selected further reading
is listed at the end of each
biography.

Darren Almond was born in Wigan in 1971. He studied at Winchester School of Art, 1990–4. Much of his work is concerned with the passing of time (as witnessed in his gigantic digital clocks) and with travel, as seen in a series of works based on train nameplates. His work has been included in group exhibitions such as *Sensation – Young British Artists from the Saatchi Collection*, 1997; and *Apocalypse*, 2000, both at the Royal Academy of Arts, London. His most recent solo exhibition was at Tate Britain, London in 2001–2. Almond lives in London.

Hamza Walker *et al.*, *Darren Almond*, Kunsthalle, Zürich, 2001
Darren Almond, Night as Day, Tate Britain, London, 2001

Richard Billingham was born in Birmingham in 1970 and graduated from the University of Sunderland in 1994. In Billingham's snapshots of his family in their council flat there is claustrophobia, passion and intimacy, amid heaped-up clutter, kitsch and filth. His photographs have been hailed as a mass of contradictions, combining documentary and fiction in their loving depiction of his family's working-class life. Billingham took part in his first group show at the Barbican Art Gallery, London, in 1994, and had a major solo exhibition at the Ikon Gallery, Birmingham in 2000. In 2001 he was nominated for the Turner Prize. He lives in Stourbridge, West Midlands.

Richard Billingham, *Ray's a Laugh*, Scalo Press, Zürich, 1996
Michael Tarantino, *Richard Billingham*, Ikon Gallery, Birmingham, 2000

Henry Bond was born in London in 1966. He studied at Goldsmiths College, London, 1985–8. He works with photography, taking impromptu shots in the street. From 1991 to 1994 he worked with Liam Gillick on a collaborative photographic project entitled *Documents*. Group

71

exhibitions include *Brilliant!*, Walker Art Center, Minneapolis, 1995.

Henry Bond, *The Cult of the Street*, Emily Tsingou Gallery, London, 1998

Christine Borland was born in Darvel, Ayrshire in 1965. She studied in the Environmental Art Department of Glasgow School of Art, 1983–7 and gained an MFA from the University of Ulster, Belfast, 1987–8. Often collaborating with non-art related institutions and professionals, Borland's work has explored ballistics, forensic science, the history of medicine and medical ethics, most recently in the developing field of human genetics. She was a Transmission committee member and had her first solo exhibition there in 1994. In 1997 she was nominated for the Turner Prize and she had a major solo exhibition at Dundee Contemporary Arts in 1999. In 2002 she won a Scottish Arts Council Creative Scotland Award as well as a commission from Glasgow University to create a Physic Garden based on a sixteenth-century herbal she found in the university's library. Borland lives in Killcreggan.

Ian Hunt and Francis McKee, *Christine Borland: The Dead Teach the Living*, Migros Museum für Gegenwartskunst, Zürich, 2000
Katrina Brown and Jonathan Jones, *Christine Borland: Progressive Disorder*, Dundee Contemporary Arts, Dundee and Bookworks, London, 2001

Martin Boyce was born in Hamilton in 1967. He did a foundation course at Glasgow School of Art, 1986–7 followed by a BA in environmental art, 1987–90. After graduating he showed his work in artist-run spaces and exhibitions organised with friends, such as a Transmission group show exchange to Bergen in 1990 with artists including Ross Sinclair and Nathan Coley. He returned to Glasgow School of Art to do an MA in environmental art, 1995–7, which included a one-semester exchange programme with the California Institute of the Arts (CAL ARTS) in Los Angeles. Boyce's practice includes wall paintings, sculpture, fictional texts and photography, which are often site-specific and critique the history of modernist design. He has had solo exhibitions at the Fruitmarket Gallery, Edinburgh in 1999 and at the Jerwood Gallery, London, 2000. Boyce lives in Glasgow.

Tom Gidley and Robert Johnston, *Martin Boyce*, Fruitmarket Gallery, Edinburgh, 1999
David Crowley, *Martin Boyce*, Jerwood Space, London, 2000

Stuart Brisley was born in Haslemere in 1933. He studied at Guildford School of Art 1949–54, the Royal College of Art 1956–9, the Akademie der Bildenden Künste, Munich 1959–60 and Florida State University 1960–2. In the 1960s and 1970s he was at the forefront of the new conceptual art movement, creating events, happenings and 'anti-performance art' from 1967. He participated in Documenta 6, Kassel, 1977.

Paul Overy *et al.*, *Stuart Brisley*, Institute of Contemporary Arts, London, 1982
Clive Philpot and Andrea Tarsia (eds.), *Live in Your Head*, Whitechapel Art Gallery, London, 2000

Roderick Buchanan was born in Glasgow in 1965. He studied in the Environmental Art Department of Glasgow School of Art, 1984–9, and at the University of Ulster, Belfast, 1989–90. Buchanan produces work in a wide variety of media including video, photography, sculpture and text and has exhibited extensively in Europe and the USA. Formal sports and more informal games feature strongly in his work, as a basis to examine how recreational activities express and communicate personal identity. In 2000 he was awarded the inaugural Beck's Futures Prize and held his first major solo exhibition at Dundee Contemporary Arts. His work was shown at the Venice Biennale in 1999 and 2001. Buchanan lives in Glasgow.

John Gill *et al.*, *Offside! Contemporary Art and Football*, Manchester City Art Galleries and the Institute of International Visual Arts, Manchester, 1996

Roderick Buchanan, *Players*, Dundee Contemporary Arts, Dundee, 2000

Helen Chadwick was born in Croydon in 1953. She studied art at Brighton Polytechnic, 1973–6 where her interest in the body as the site of identity was expressed in buttock- and thigh-shaped cushions made of silk and embroidered with human hair. Between 1976 and 1977 she gained an MA from Chelsea School of Art and Design, London. In 1986 she was artist-in-residence at Birmingham City Museum and she was twice nominated for the Turner Prize. She explained: 'Most of my works of art crystallise in that reverie between sleep and wakefulness, when you idle into neutral and follow funny little chains of thought.' Her 1994 solo show at the Serpentine Gallery, London, was critically acclaimed and included a centrepiece of an erotic chocolate fountain. The majority of her works are three-dimensional, but she also worked in video and with installations involving slide projections. Chadwick died in 1996.

Helen Chadwick *et al.*, *Effluvia*, Serpentine Gallery, London, 1994

Marina Warner *et al.*, *Stilled Lives: Helen Chadwick*, Portfolio Gallery, Edinburgh, 1996

Jake and Dinos Chapman: Dinos was born in Cheltenham in 1962 and studied at Ravensbourne Art School, 1979–81, then worked as an assistant to Gilbert and George. Jake was born in London in 1966, and studied at North London Polytechnic, 1985–8. Both studied at the Royal College of Art, London, 1988–90. They began working together in 1992, producing highly provocative, sexually explicit mannequin sculptures. Their work was included in the *Sensation* and *Apocalypse* exhibitions at the Royal Academy of Arts, London in 1997

and 2000. Solo shows include *Chapmanworld* at the Institute of Contemporary Arts, London in 1996 and at White Cube², London in 2002. Jake and Dinos Chapman live in London.

Douglas Foyle *et al.*, *Chapmanworld*, Institute of Contemporary Arts, London, 1996

Jake Chapman, *Unholy Libel*, Gagosian Gallery, New York, 1997

Alan Charlton was born in Sheffield in 1948. He studied at Camberwell School of Art, London 1966–9, and at the Royal Academy, London, 1969–72. Since 1969 he has painted exclusively in monochrome grey; moreover the scale of his works are always divisible by a 4.5cm unit (the depth of the canvas on its stretcher). His solo exhibitions include those held at the Stedelijk van Abbemuseum, Eindhoven in 1982, and at the Museum Haus Esters, Krefeld in 1992. Charlton lives in London.

Emile Charlton, *Alan Charlton*, Hallen für Neue Kunst, Schaffhausen, 1991

Quad, Galerie Stadtpark, Krems, 1995

Mat Collishaw was born in Nottingham in 1966. He studied at Trent Polytechnic, Nottingham, 1985–6, and Goldsmiths College, London, 1986–9. He works with video, installation and photography. His work has been included in group exhibitions such as *Freeze*, London, 1988, *Modern Medicine*, London, 1990, and *Brilliant!*, Walker Art Center, Minneapolis, 1995. Solo exhibitions include those at Karsten Schubert Ltd, London, 1990, Lisson Gallery, London, 1997, and Galleria d'Arte Moderna, Bologna, 1999. Collishaw lives in London.

Jon Thompson, *Mat Collishaw*, Artimo Foundation, Amsterdam, 1997

A Contemporary Cabinet of Curiosities: Selections from the Vicki and Kent Logan Collection, California College of Arts and Crafts, Oakland, 2001

John Coplans was born in London in 1920. He held his first exhibition of paintings in 1957 at the New Vision Gallery, London. He moved to America in 1960 and in 1962 was one of the founders of *Artforum* magazine. During the 1960s and 1970s he worked as a writer and curator. He began taking photographs in 1979, and made the first photographs of his naked body in 1984. He has explored this theme ever since. His first photographic exhibition was held at the Art Institute of Chicago in 1981 and he had a solo exhibition at the Scottish National Gallery of Modern Art in 1999. Coplans lives in New York.

John Coplans *et al., John Coplans: A Self-portrait 1984–1997*, p.s. 1 Contemporary Art Center, New York, 1997

Martin Hammer, *John Coplans: A Self-portrait 1984–1999*, National Galleries of Scotland, Edinburgh, 1999

Tony Cragg was born in Liverpool in 1949 and worked as a laboratory technician before studying at Wimbledon School of Art and the Royal College of Art, London, 1973–7. His first solo exhibition was at Lisson Gallery, London in 1979 and he has exhibited regularly ever since. In 1977 he moved to Germany and began to teach at the Kunstakademie, Düsseldorf, of which he is now co-director. At first his work was made of cheap, 'everyday' materials, and in the 1980s he became internationally known for his wall and floor assemblages composed of found pieces of coloured plastic and other detritus. In the late 1980s Cragg made his first cast sculptures, and from this time recycled or found objects began to appear less in his work. In 1988 he represented Britain at the Venice Biennale and in the same year won the Turner Prize. In 1996 he was elected a Royal Academician. Tate Liverpool mounted a major retrospective of his work in 2000. Cragg lives in Wuppertal, Germany.

Lucinda Barnes *et al., Tony Cragg; Sculpture 1975–1990*, Thames & Hudson, London, 1991

Lewis Biggs *et al., A New Thing Breathing: Recent Work by Tony Cragg*, Tate Liverpool, Liverpool, 2000

Alan Davie was born in Grangemouth in 1920. He studied at Edinburgh College of Art, 1937–40. He served in the Royal Artillery until 1946 and developed a strong interest in poetry and jazz. From the late 1940s he developed a gestural abstract style. He has shown regularly with Gimpel Fils Gallery, London, since 1950. Retrospective exhibitions include those held at the Whitechapel Art Gallery, London, 1958; Stedelijk Museum, Amsterdam, 1962; McLellan Galleries, Glasgow, 1992, and Scottish National Gallery of Modern Art, 2000. Davie lives in Hertfordshire and Cornwall.

Douglas Hall, *Alan Davie*, Lund Humphries, London, 1992

Patrick Elliott, *Alan Davie: Work in the Scottish National Gallery of Modern Art*, National Galleries of Scotland, Edinburgh, 2000

Tacita Dean was born in Canterbury in 1965. She studied at Falmouth School of Art, 1985–8 and Slade School of Fine Art, London, 1990–2. She has held artist's residencies at the Ecole Nationale des Beaux-Arts, Bourges and at the Wexner Center for the Arts, Columbus, Ohio. In 1998 she was nominated for the Turner Prize. In 2001 Tate Britain staged a survey exhibition of her work from the mid-1990s. Dean works with photography, film, drawing and sound, often accompanied by texts. She is concerned with navigation, time, landscape and narrative, and the sea features prominently in her work. In 2001 she published the artist book *FLOH*, in collaboration with Martyn Ridgewell, featuring a collection of photographs acquired from flea markets. Dean lives in Berlin.

Clarrie Wallis *et al., Tacita Dean*, Tate Publishing, London, 2001

Dominic Denis, who is of Jamaican origin, was born in London in 1963 and grew up in Leeds. He studied at Chelsea School of Art and Design, 1984–6 and Goldsmiths College, London, 1986–9. His solo exhibitions include those held at Galerie Harry Zellweger, Basel, 1991 and Anthony Wilkinson Gallery, London, 1996. Group shows include *London / Screen* held at The Whitworth Art Gallery, Manchester, 1999. Denis lives in London.

London / Screen, The Whitworth Art Gallery, Manchester, 1999

Sara Roberts, *Multiple Choice*, The British Council, London, 2001

Kenneth Dingwall was born in Devonside, Clackmannanshire in 1938. He attended Edinburgh College of Art, 1955–60, and Athens School of Fine Art, 1961–2. His large-scale abstract works are inspired by nature, their patterns resembling the shift of sunlight or the solidity of landscapes, whilst resonating with a psychological exploration of surfaces, membranes and what is hidden beneath the surface. His works are painted in a limited range of colours: blue, red, black, and most often grey. Since the 1970s he has worked as a visiting artist and professor in many institutions including the University of Wisconsin, Minneapolis College of Art, Yale University and the Cleveland Institute of Art. Dingwall lives in Cleveland, Ohio.

Paul Overy, *Kenneth Dingwall*, Scottish Arts Council, Edinburgh, 1977

Duncan Macmillan, *Kenneth Dingwall: Paintings and Drawings 1990–1996*, Talbot Rice Gallery, Edinburgh, 1996

Jacqueline Donachie was born in Glasgow in 1969. She graduated from Glasgow School of Art in 1991, where she had studied in the Environmental Art Department. Donachie works across a variety of media including sound, installation and video to explore personal histories and social interactions while emphasising the participatory aspect of viewing art. She served on the committee of Glasgow's Transmission and her first solo show was held at Tramway, Glasgow, in 1994. The following year she travelled to Hunter College, New York on a Fulbright Fellowship. In 2001 she was awarded a Henry Moore Fellowship at Spike Island, Bristol. Donachie lives in Glasgow.

Claire Doherty, *Jacqueline Donachie: South*, Spike Island, Bristol, 2001

Tracey Emin was born in London in 1963, and grew up in Margate. She gained a BA in fine art at Maidstone College of Art, 1983–6 and an MA from the Royal College of Art, London in 1989. Emin's art is one of disclosure, using her life events in works ranging from story-telling, drawing, film-making, installation, painting, neon, photography, appliquéd blankets and sculpture. In 1993 she set up The Shop with Sarah Lucas at 103 Bethnal Green Road, London where they sold their own work. Her first solo exhibition, at White Cube, London in 1994, was called *My Major Retrospective*. She was shortlisted for the Turner Prize in 1999 and has won various awards including the Eighth Cairo International Biennale Jury Prize in 2000. She has had major solo exhibitions in New York, Berlin, Istanbul, Montreal and Japan and most recently at White Cube[2], London in 2001. Emin lives in London.

Neal Brown *et al.*, *Tracey Emin*, White Cube, London, 1998

Tracey Emin, *Tracey Emin*, Booth-Clibborn Editions, London, 2002

Angus Fairhurst was born in Kent in 1966. He studied at Canterbury College of Art, 1985–6 and at Goldsmiths College, London, 1986–9. He works in a variety of media, from painting to sculpture and film, and often deals with the theme of repetition; he is also a member of the band, *Low Expectations*. His solo exhibi-

tions include those held at Karsten Schubert Ltd, London 1990–4, Sadie Coles HQ, London in 1998 and the Ursula Blickle Stiftung, Kraichtal in 1999. Group exhibitions include *Freeze* 1988, and *Gambler* and *Modern Medicine*, both 1990, all held in London, where Fairhurst lives.

Yilmar Dziewior *et al.*, *Angus Fairhurst*, Ursula Blickle Stiftung, Kraichtal, 1999

David Faithfull was born in Edinburgh in 1961. He studied visual communications at Duncan of Jordanstone College of Art and Design, Dundee, graduating in 1993 and now teaches graphic design there, part-time. He works as a commercial designer as well a visual artist. In 1999 he was commissioned to produce work for the opening of the Scottish Parliament. The format of the artist book appeals to him in part due to its interactive nature and its status as part of an edition, bridging the divide between viewer and object. Recent bookworks have explored Scottish coastlines through image and text, sometimes using palindromic form. His work was selected for *Type: Aesthetic & Function* at the Kansas Wesleyan University Art Center, which toured to Duncan of Jordanstone College in 2002. Faithfull lives in Edinburgh.

Alec Finlay (ed.), *Passport*, Morning Star Publications, Edinburgh, 1999
Alec Finlay (ed.), *Without Day*, Pocketbooks, Edinburgh, 2000

Ian Hamilton Finlay was born to Scottish parents in 1925 in Nassau and grew up in Scotland. Following a brief period at Glasgow School of Art he was called up and saw service in Germany. He began writing short stories and poems in the 1950s, and in the 1960s began combining words with visual imagery. In 1961 he was co-founder of the Wild Hawthorn Press, which has published many of his printed works. Finlay has developed a challenging and complex fusion of poetry, graphic art, sculpture and landscape gardening, using in particular the themes of militarism, politics, art and classicism. He frequently makes an analogy between these forces and the forces of nature, highlighting the thin line that divides creation and destruction. In 1966 he moved to an isolated farmhouse in the Pentland Hills to the south of Edinburgh. There he has created his most celebrated achievement, a remarkable sculpture garden named Little Sparta, which is dedicated to the classical tradition and its counterparts. Finlay was appointed CBE in 2002. Major exhibitions include those held at the Deichtorhallen, Hamburg in 1995 and at Tate St Ives in 2002. Finlay lives in Lanarkshire.

Yves Abrioux, *Ian Hamilton Finlay: A Visual Primer*, Reaktion Books, London, 1992
Rosemarie E. Pahlke and Pia Simig (eds.), *Ian Hamilton Finlay: Prints 1963–1997*, Cantz Verlag, Ostfildern, 1997

Moyna Flannigan was born in Kirkcaldy in 1963. She studied drawing and painting at Edinburgh College of Art, 1981–5 and gained an MFA at Yale University School of Art, New Haven, Connecticut, 1985–7. Flannigan is known for her fictional portraits based on wry and penetrating observations of middle-class society. She was a Scottish Arts Council scholar at the British School at Rome in 1997 and a finalist in the Natwest Art Prize in 1999. Her solo exhibitions include those held at the Centre for Contemporary Arts, Glasgow in 1996, Galerie Albrecht, Munich in 2000 and at Sara Meltzer Gallery, New York in 2002. She lectures at Glasgow School of Art, and lives in Edinburgh.

Angela Kingston, *Moyna Flannigan*, Centre for Contemporary Arts, Glasgow, 1996
Tim Marlow, *The NatWest Art Prize 1999*, Lothbury Gallery, London, 1999

Lucian Freud was born in Berlin in 1922 and is the grandson of Sigmund Freud. He moved to London in 1933. From 1938 until

1943 he studied at the Central School of Arts and Crafts, London, the East Anglian School of Painting and Drawing, and at Goldsmiths College, London. He acquired British nationality in 1939. Between 1949 and 1954 he was a visiting tutor at the Slade School of Fine Art, London. While Freud's work from the 1940s has a hallucinatory quality derived from his interest in Surrealism, his art has always been based on intense observation of the real world. His paintings are usually of people (the same friends, family members or paid models) and are the result of long, probing sittings. In the late 1950s his meticulous, illusory style gave way to a greater use of painterly brushwork and dramatic use of light. Throughout his career he has received consistent recognition for his technically brilliant works of almost unnerving psychological intensity. Major touring shows have been mounted by the Whitechapel Gallery, London in 1993 and by Tate Britain in 2002. Freud lives in London.

Craig Hartley, *The Etchings of Lucian Freud: A Catalogue Raisonné 1946–1995*, Marlborough Graphics, London, 1995

Bruce Bernard and Derek Birdsall (eds.), *Lucian Freud*, Jonathan Cape, London, 1996

Hamish Fulton was born in London in 1946. He studied at Hammersmith School of Art, London, 1964–5; Central St Martin's School of Art and Design, London 1966–8; and the Royal College of Art, London, 1968–9. In the 1960s, along with other artists such as Richard Long and Gilbert and George, he began to explore the possibilities of conceptual sculpture. He sought to create a new form of landscape art based upon his direct engagement with his environment. From 1969 onwards Fulton has conducted walks in dozens of countries around the world, including Scotland. He exhibits and publishes photographic and textual records of the walks which allow his experience to be shared with a wider audience, but these works are secondary – for Fulton the walk is the art. Solo exhibitions include those held at the Kunstmuseum, Basel, 1975; Stedelijk van Abbesmuseum, Eindhoven, 1985; Albright-Knox Art Gallery, Buffalo, 1990, and Tate Britain, London, 2002. Fulton lives near Canterbury, Kent.

Angela Vettese, *Hamish Fulton, Walking Artist*, Richter Verlag, Hamburg, 2001

Ben Tufnell and Andrew Wilson, *Hamish Fulton: Walking Journey*, Tate Publishing, London, 2002

Anya Gallaccio was born in Glasgow in 1963. She studied at Goldsmiths College, London, 1985–8. She works with materials which decay: flowers, ice (including a 35-ton block), fruit, and conceives this approach as a collaborative venture in which the putrefying materials – which are both seductive and dying – play their part. Her work has been included in various group exhibitions such as *Broken English*, Serpentine Gallery, London, 1991, the touring *British Art Show 4*, 1995, and *Releasing the Senses*, Tokyo Opera City, 1999. Solo exhibitions include those held at Karsten Schubert Ltd, London, in 1991 and Delfina, London, 1998. Gallaccio lives in London.

Patricia Bickers, 'Meltdown', *Art Monthly*, no.195, 1996

Ralph Rugoff, *Chasing Rainbows*, Tramway, Glasgow, 1999

Liam Gillick was born in Aylesbury, Buckinghamshire, in 1964. He studied at Hertfordshire College of Art and Goldsmiths College, London. He works with photography, text and installations, using a documentary approach. From 1991 to 1994 he worked with Henry Bond on a collaborative photographic project entitled *Documents*. Solo exhibitions include those held at the Hamburg Kunstverein, 1999, Hayward Gallery, London, 2000, and Whitechapel Art Gallery, London, 2002.

His work has been included in group shows such as Documenta X, Kassel, 1997 and *The British Art Show 5*, 2000. Gillick was nominated for the 2002 Turner Prize. He lives in London and New York.

Iwona Blazwick *et al.*, *Liam Gillick: The Wood Way*, Whitechapel Art Gallery, London, 2002

Douglas Gordon was born in 1966 in Glasgow. He trained at Glasgow School of Art, 1984–8 and Slade School of Fine Art, London, 1988–90. Gordon's work moves between text, video, photography, painting and installation. Much of his material is 'found' rather than invented. Ambiguity and disruption of normal, accepted ways of seeing the world are central concerns. Gordon is also fascinated with our binary nature and our tendency to split things into opposites (black and white, good and evil). He has received several prizes and awards, including the 1996 Turner Prize, the Premio 2000 at the 1997 Venice Biennale and the 1998 Central Art Prize of the city of Cologne. Of the many shows that he has been in, key solo ones include: *24 Hour Psycho*, Tramway, Glasgow, 1993; *Close Your Eyes, Open Your Mouth*, Museum für Gegenwartskunst, Zürich, 1996; *Kidnapping*, Stedelijk van Abbemuseum, Eindhoven, 1998; *Sheep and Goats*, Musée d'Art Moderne de la Ville de Paris, 2000; *Black Spot*, Tate Liverpool, 2000 and *Douglas Gordon*, The Museum of Contemporary Art, Los Angeles, 2001–2. Gordon lives in Glasgow and New York.

Mark Francis (ed.), *Douglas Gordon: Black Spot*, Tate Gallery Publishing, London, 2000
Russell Fergusson, *Douglas Gordon*, Los Angeles Museum of Contemporary Art, Los Angeles, 2001
Herbert Abrell, *Douglas Gordon*, Kunsthaus Bregenz, Bregenz, 2002

Siobhán Hapaska was born in Belfast in 1963. She studied at Middlesex Polytechnic, 1985–8, and then at Goldsmiths College, London, 1990–2. She has made highly finished, streamlined sculptures, which are bizarrely shaped yet seem machine made. Her work has been shown in various group exhibitions including *Wonderful Life*, Lisson Gallery, London, 1993. Solo exhibitions include those held at the Institute of Contemporary Arts, London, 1995, Entwistle Gallery, London, 1997 and the Konsthall, Stockholm, 2000. Hapaska lives in London.

Ingrid Swenson *et al.*, *Siobhán Hapaska: St Christopher's Legless*, Institute of Contemporary Arts, London, 1995
Siobhán Hapaska, Stockholm Konsthall, Stockholm, 2000

Damien Hirst was born in Bristol in 1965 and grew up in Leeds. He studied at Leeds College of Art, then Goldsmiths College, London, 1986–9. He organised the exhibitions *Freeze*, 1988, *Gambler*, 1990 and *Modern Medicine*, 1990, all held in London, which launched the reputations of a new generation of young artists, including his own. Much of his work deals with the theme of death, sometimes represented through the agency of pharmaceutical products, sometimes more directly with dead animals. He won the Turner Prize in 1995. His work has been shown in numerous mixed exhibitions including *Young British Artists I* at the Saatchi Gallery, 1992. Solo exhibitions include those held at the Institute of Contemporary Arts, London, 1991, and Gagosian Gallery, New York, 1996 and 2000. Hirst lives in Devon.

Damien Hirst, *Damien Hirst: I want to spend the rest of my life everywhere, with everyone, one to one, always, forever, now*, Booth-Clibborn Editions, London, 1997
Damien Hirst and Gordon Burn, *On the Way to Work*, Faber and Faber, London, 2001

Howard Hodgkin was born in London in 1932. During the Second World War he was evacuated to New York. Between 1949 and 1954 he studied at Camberwell School of Art, London, and at Bath Academy of Art, Corsham, where he subsequently

taught. He first exhibited in the early 1960s and in these paintings established the pattern of his art, using recollections of personal events or social activities as the basis for his imagery. His paintings of the 1970s onwards (from which time he became internationally known) maintain the geometric composition of his earlier work, but with an increased and more gestural use of layered colour, decorative pattern and surface effect. While the titles of his works make reference to a particular subject – primarily portraits or domestic situations – they appear as abstract, painterly evocations of a remembered moment, rather than as a literal representation. He represented Britain at the Venice Biennale in 1984 and won the Turner Prize in 1985. A major touring exhibition of his work began at the Metropolitan Museum of Art, New York in 1995, and an exhibition of his large paintings from 1984 until 2002 was held at the Scottish National Gallery of Modern Art in 2002. He was appointed CBE in 1977 and knighted in 1992. Hodgkin lives in London.

Michael Auping et al., Howard Hodgkin Paintings, Modern Art Museum of Fort Worth, Texas 1995
Andrew Graham-Dixon, Howard Hodgkin, Thames & Hudson, London, 2001
Robert Rosenblum and Richard Kendall, Howard Hodgkin: Large Paintings 1984–2002, National Galleries of Scotland, Edinburgh, 2002

Louise Hopkins was born in Hertfordshire in 1965. She studied at Newcastle-upon-Tyne Polytechnic and Glasgow School of Art, where she completed her MA in 1994. Her first solo exhibition in the United Kingdom was at Aberdeen Art Gallery in 1994. She was shortlisted for the Jerwood Painting Prize in 1997. Over the last ten years Hopkins's work has been concerned with the transformation of pre-existing surfaces, including furnishing fabrics, song sheets, pages from history books and printed maps. She has had regular solo exhibitions since 1992, including those at

Andrew Mummery Gallery, London in 1999 and at Angles Gallery, Santa Monica, California in 2001. In 2002 Hopkins won a Scottish Arts Council Creative Scotland Award. She lives in Glasgow.

Tony Godfrey, Louise Hopkins, Tramway, Glasgow, 1996
Catherine Lepdor et al., Open Country: Contemporary Scottish Artists, The British Council, Lausanne, 2001

Gary Hume was born in Kent in 1962. He studied at Goldsmiths College, London, 1985–8. His early paintings, executed in household gloss paint, were based on hospital doors. His subsequent paintings are more figurative but are painted in the same shiny, glossy paints on metal panels. His work has been shown in group exhibitions such as *Freeze*, London, 1988, and the touring *The British Art Show 3*, 1990. He was shortlisted for the Turner Prize in 1996, and won the Jerwood Painting Prize in 1997. He represented Britain at the 1999 Venice Biennale. Solo exhibitions include those held at the Scottish National Gallery of Modern Art, Edinburgh, and Whitechapel Art Gallery, London, both in 1999. Hume lives in London.

Keith Hartley, Gary Hume: New Work, National Galleries of Scotland, Edinburgh, 1999
David Batchelor et al., Gary Hume, Whitechapel Art Gallery, London, 1999

Callum Innes was born in Edinburgh in 1962. He studied at Grays School of Art, Aberdeen 1980–4 and gained a postgraduate diploma at Edinburgh College of Art, 1984–5. He was awarded the Scottish Arts Council's Amsterdam residency in 1987, was short-listed for the Turner Prize in 1995 and won the 2002 Jerwood Painting Prize. The year he spent in Amsterdam was crucial to the development of his art. Up to that time he was still painting in a figurative idiom, but the experience of seeing, amongst other things, an exhibition of work by Lucio Fontana taught him

79

that a combination of minimal means (monochrome canvases) and subtractive gestures (the slashing and puncturing of canvases) could conjure up a sense of life lived, of human existence, more subtly and poignantly than many a figurative painting. Innes has had numerous solo shows in Edinburgh, Antwerp, Zürich, Paris, Düsseldorf, Amsterdam, New York, Birmingham, Dublin and Bern. He lives in Edinburgh.

Marco Livingstone, *Callum Innes*, Irish Museum of Modern Art, Dublin, 1999

Marco Livingstone, *Callum Innes: Exposed Paintings*, Callum Innes and the Ingleby Gallery, Edinburgh, 2001

Leon Kossoff was born in London in 1926. He studied at Central St Martin's School of Art and Design, 1949–52. From 1950 until 1952 he attended evening classes taught by David Bomberg at the Borough Polytechnic, London. He went on to study at the Royal College of Art, 1953–6. London is Kossoff's principal subject and he has lived in the area around Mornington Crescent, Willesden and Kilburn all his life. In common with Auerbach and the other 'School of London' artists with whom he is often linked, Kossoff has concentrated on portraits of family and close friends and, in particular, on London landscapes. Major exhibitions of his work include those held at the Museum of Modern Art in Oxford, 1981 and a retrospective at the Tate Gallery, London in 1996. In 1995 he represented Britain at the Venice Biennale. Kossoff lives in London.

Paul Moorhouse, *Leon Kossoff*, Tate Gallery Publishing, London, 1996

Klaus Kertess, *Leon Kossoff*, Annely Juda Fine Art, London, 2000

Jim Lambie was born in Glasgow in 1964. After school he became involved with the local music scene and played the xylophone in the band *The Boy Hairdressers*. He studied in the Environmental Art Department of Glasgow School of Art, 1990–4. After graduation he was amongst a group of students, including David Shrigley, Douglas Gordon and Roderick Buchanan, who arranged exhibitions of their work in non-traditional spaces from empty garages to their own bedrooms. Lambie's first solo exhibition was at Transmission, Glasgow in 1999, for which he made his celebrated *ZOBOP*, a floor-based installation of multi-coloured stripes of glossy vinyl tape. Lambie lives in New York.

Rob Tufnell, *ZOBOP*, Transmission , Glasgow, 1999

Michael Landy was born in London in 1963. He studied at Loughborough College of Art, 1981–3 and Goldsmiths College, London, 1985–8. Much of his work deals with the theme of consumption and consumer waste. In 1993 he established a fictitious company, Scrapheap Services, and produced a huge installation of rubbish which commented upon recession and unemployment. Landy's work has been included in numerous group exhibitions including *Freeze*, London, 1988, *Brilliant!*, Walker Art Center, Minneapolis, 1995 and *Sensation* at the Royal Academy of Arts, London, 1997. He has had several solo exhibitions at Karsten Schubert Ltd, London, 1989–93, as well as *Market*, 1990 and *Scrapheap Services*, Chisenhale Gallery, London, 1996. In 2001 he destroyed all his possessions in an exhibition entitled *Break Down*, held in the former C & A store in Oxford Street, London. Landy lives in London.

Michael Landy, *Scrapheap Services*, Chisenhale Gallery and Ridinghouse Editions, London, 1996

Julian Stallabrass, *Michael Landy: Break Down*, Artangel, London, 2001

Abigail Lane was born in Penzance in 1967. She studied at Bristol Polytechnic, 1985–6 and Goldsmiths College, London, 1986–9. She explores the traces and imprints people leave behind them, basing one series on rubber ink-stamps of her

fingerprints, and another on the footprints of a friend. Solo exhibitions include those held at Karsten Schubert Ltd, London, 1992, the Institute of Contemporary Arts, London, 1995, the Museum of Contemporary Art, Chicago, 1998 and Milton Keynes Gallery, 2001. She lives in London.

Staci Boris, *Abigail Lane: Whether the Roast Burns the Train Leaves or the Heavens*, Museum of Contemporary Art, Chicago, 1998

Steven Bode *et al.*, *Abigail Lane: Tomorrow's World, Yesterday's Fever (Mental Guests Incorporated)*, Milton Keynes Gallery / Film and Video Umbrella, Milton Keynes, 2001

Langlands and Bell: Ben Langlands was born in London in 1955 and Nikki Bell was born in London in 1959. They both studied at Middlesex Polytechnic, London, 1977–80, and have worked together ever since. They are widely known for their enigmatic relief constructions based on architectural plans. These reliefs, begun in 1986 and initially incorporated into furniture, are represented either as ground plans or as isometric views. They are generally made in low relief in white-painted wood, MDF and lacquer, and are presented as framed and glazed constructions. The buildings often have a utopian agenda and invariably a strategic brief, and include prisons, churches, synagogues, art galleries, company headquarters and geo-political organisations. Langlands and Bell exhibitions include those held at the Serpentine Gallery, London, 1996 and the Yale Center for British Art, New Haven, 1999. They live in London.

Adrian Dannant, *Langlands and Bell*, Langlands and Bell / Paley Wright Interim Art, London, 1991

Germano Celant, *Langlands and Bell*, Serpentine Gallery, London, 1996

Sarah Lucas was born in London in 1962. After preliminary studies at the Working Men's College, 1982–3 and London College of Printing, 1983–4 she attended Goldsmiths College, London, from where she graduated in 1987. She exhibited in key group shows such as *Freeze*, 1988, *Minky Manky*, 1995 and *Sensation*, 1997, all held in London. In 1993 she founded The Shop with Tracey Emin in Bethnal Green, London, where they sold their own work. Lucas has embraced self-portraiture, often representing herself in self-consciously masculine poses. Playing with traditional gender roles and stereotypes is a feature of her work, such as her anthropomorphic furniture where everyday objects stand in for sexual organs. While these works are often seen as confrontational or shocking, this is tempered by an element of humour and parody. Lucas was the subject of the 1996 BBC documentary *Two Fried Eggs and a Stinking Fish*. She lives in London.

Jerry Saltz *et al.*, 'Matthew Barney, Sarah Lucas and Roman Signer', *Parkett*, no. 45, Zürich 1995

Brigitte Kölle, *Sarah Lucas*, Portikus, Frankfurt-am-Main, 1996

Chad McCail was born in Manchester in 1961 and grew up in Edinburgh. He read english at the University of Kent, Canterbury, 1979–83, took a foundation course at Cumbria College of Art and Design, 1985–6 and gained a BA at Goldsmiths College, London, 1986–9. After graduating he spent a year in Dunsyre painting landscapes before returning to Edinburgh where he participated in several group shows including *Ariel*, 1994. McCail's main interest is the link between sexual suppression and violence and how they lead to social conformity. His densely-coloured, simplified billboard-like images are populated by people and beanie stickmen in harmonious situations, accompanied by idealistic captions such as 'wealth is shared' and 'no one charges no one pays', illustrating how society can be improved by such actions. His first solo exhibition was shown at the Collective Gallery, Edinburgh and Laurent Delaye

81

Gallery, London in 1994 and in 2000 he was shortlisted for the inaugural Beck's Futures Prize. His most recent solo exhibition took place at Laurent Delaye Gallery in 2002. McCail lives in Edinburgh.

John Calcutt *et al.*, *Here and Now*, Dundee Contemporary Arts, Dundee, 2001

Chad McCail and Jeremy Akerman, *Active Genital*, Bookworks, London, 2002

Will Maclean was born in Inverness in 1941. After attending Inverness Royal Academy he worked as a sailor. He then gained a diploma and post-graduate diploma in painting at Gray's School of Art, Aberdeen, 1961–5, after which he spent a short time as a ring-net fisherman on Skye, before training as a teacher in Dundee. He works in both two and three dimensions, but is perhaps best known for his box-constructions incorporating found or carved objects. His work explores his interest in the culture and history of the Scottish Highlands, maritime themes and museums. In 1981 Maclean was appointed a lecturer at Duncan of Jordanstone College of Art and Design, Dundee, becoming a professor in 1994. In 1991 he was elected a Royal Scottish Academician. His most recent major solo exhibition was held at Dundee Contemporary Arts in 2001. Maclean lives in Tayport, Fife.

Duncan Macmillan, *Symbols of Survival: the Art of Will Maclean*, Mainstream Publishing, Edinburgh, 1992

Wendy McMurdo was born in Edinburgh in 1962. She studied painting at Edinburgh College of Art, 1980–5 before spending two years at the Pratt Institute, Brooklyn, New York from 1986. On her return to Edinburgh she was artist-in-residence at the City Art Centre before doing an MA at Goldsmiths College, London, 1991–3. Between 1994 and 1996 she was twice appointed a Henry Moore Research Fellow, in print technologies, and was based at Sheffield Hallam University. These proved formative years in her career, allowing her the opportunity to explore how digital technology effects printmaking, or more generally, the implications of the computer for fine art photography and how notions of identity are changing in the face of developing technology. Her solo exhibition *In a Shaded Place* was toured around the United Kingdom by the Site Gallery in 1995 and throughout Europe by the British Council. In 2001 she was commissioned by the Scottish National Portrait Gallery to photograph the Roslin Institute scientists who created the cloned sheep, Dolly. In January 2002 McMurdo won a Scottish Arts Council Creative Scotland Award which will help fund a project exploring the shipwrecks at Scapa, Orkney. McMurdo lives in Edinburgh.

Francis McKee and Gilda Williams, *Wendy McMurdo*, Salamanca, 2001

Nicholas May was born in Limavady, Northern Ireland, in 1962. He studied at Bath Academy of Art, 1981–4 and Goldsmiths College, London, 1988–90. Solo exhibitions include those held at the John Hansard Gallery, Southampton in 1990 and South London Gallery in 1994. May lives in London.

Adrian Searle, *Nicholas May*, John Hansard Gallery, Southampton, 1990

Stephen Snoddy (ed.), *Nicholas May*, South London Gallery, London, 1994

Victoria Morton was born in Glasgow in 1971. She studied at Glasgow School of Art, 1989–95. She had several solo exhibitions in 1996, including one at Transmission, Glasgow. She played bass in the band *Suckle* until the end of 2001 and is now in a new band. In 1997 she co-founded the performance and installation group *Elizabeth Go*. Her first solo exhibition in England was held at Andrew Mummery Gallery in London in 1997. In her exhibi-

tion DECAPODA at The Changing Rooms, Stirling, Morton introduced sculpture and video to her practice. She has been commissioned by the Fruitmarket Gallery, Edinburgh, to make a new body of work, as part of their *Visions of the Future* series of exhibitions of work by young Scottish artists. Morton lives in Glasgow.

Pat Fisher, *Intelligible Lies*, Talbot Rice Gallery, University of Edinburgh, Edinburgh, 1998
Heather Alle *et al.*, *DECAPODA*, The Changing Rooms, Stirling, 1999

Julian Opie was born in London in 1958. He studied at Goldsmiths College, London, 1979–82 and had his first solo exhibition the following year, at Lisson Gallery, London. Opie has developed his practice from folded-steel sculptures painted with trompe l'oeil surfaces, to hard-edged minimalist pieces, to simplified portraits and exhibitions devised as single all-encompassing installations. He has exhibited internationally since the beginning of the 1980s and is currently working on a project for the Museum of Modern Art, New York. Opie lives in London.

Lynne Cook *et al.*, *Julian Opie*, Thames and Hudson, London, 1993
Jonathan Watkins, *Julian Opie*, Ikon Gallery, Birmingham, 2001

Jonathan Owen was born in Liverpool in 1973. He studied at Leeds Metropolitan University and then at Edinburgh College of Art, 1998–2000. He has had solo exhibitions at the Collective Gallery, Edinburgh, 2000, and doggerfisher, Edinburgh, 2001. He lives in Edinburgh.

Elizabeth Mahoney, 'Profile: Jonathan Owen', *Art Review*, June 2001

Eduardo Paolozzi was born in Leith, Edinburgh in 1924. He studied at Edinburgh College of Art, 1941–3. After war service he went to the Ruskin School of Art, Oxford in 1944 and then the Slade School of Fine Art, London from 1945–7.

Inspired by Surrealism, Paolozzi went to Paris for two years from 1947 where he was befriended by Alberto Giacometti. Early collages using American popular imagery led to the Bunk! lecture of 1952 which introduced pulp literature as an art form. In the sixties Paolozzi explored engineering as a means of making abstract geometric sculptures or 'machine idols'. During the sixties and seventies he made pioneering pop art prints. In the 1980s he returned to the human image. Surrealism, collage and the juxtaposition of disparate images have been at the heart of his work. He is hailed as a father of Pop Art but prefers to be known as a radical Surrealist. Paolozzi was a part-time tutor in ceramics at the Royal College of Art, 1968–89, after which he spent two years as professor of sculpture at the Akademie der bildenden Künste, Munich. He had a retrospective exhibition at the Tate Gallery, London in 1971, and has had several international touring exhibitions including *Recurring Themes*, 1984 and *Artificial Horizons and Eccentric Ladders*, 1996. In 1995 he donated the contents of his studio plus a substantial amount of his work to the National Galleries of Scotland. As a result, a re-creation of his studio was constructed in the Dean Gallery, the sister building to the Scottish National Gallery of Modern Art, which opened in March 1999.

Fiona Pearson, *Eduardo Paolozzi*, National Galleries of Scotland, Edinburgh, 1999
Robin Spencer, *Eduardo Paolozzi: Writings and Interviews*, Oxford University Press, Oxford, 2001

Marc Quinn was born in London in 1964. He studied history and history of art at Cambridge University, 1982–5. He worked as an assistant to sculptor Barry Flanagan, 1982–6. In 1991 he made *Self*, a cast replica of his head, made from his own frozen blood. Since then Quinn has made a number of works based on casts, often of his own body. Another series is based on frozen plants and flowers suspended in

silicone. Both series deal with the theme of death and decay. Solo exhibitions include those held at the Tate Gallery, London, 1995, Fondazione Prada, Milan, 2000, White Cube², London, 2000 and Tate Liverpool, 2002. Quinn lives in London.

Diana Allan (ed.), *Marc Quinn: Incarnate*, Booth-Clibborn Editions, London, 1998

Christoph Grunenberg and Victoria Pomery (eds.), *Marc Quinn*, Tate Publishing, London, 2002

Carol Rhodes was born in Edinburgh in 1959. She grew up in Bengal and returned to the United Kingdom, aged fourteen, to complete her education. She studied painting at Glasgow School of Art, 1977–82. After graduating, Rhodes joined the committee of the artist-run Transmission, Glasgow and became involved with the Free University of Glasgow. She resumed painting in 1990, following a five-year gap, and held her first solo exhibition at the Andrew Mummery Gallery, London in 1998. She is known for her paintings of fictional, apparently insignificant land-scapes, often viewed from an aerial perspective. Rhodes is currently on a three-year research fellowship at Glasgow School of Art. She lives in Glasgow.

Pat Fisher, *Intelligible Lies*, Talbot Rice Gallery, University of Edinburgh, Edinburgh, 1998

Jane Lee, *Carol Rhodes*, Tramway, Glasgow, 2000

James Rielly was born in Holyhead, north Wales in 1956. He studied at Deeside College, 1974–5 and Gloucester College of Art and Design, 1975–8, before completing an MA at Belfast College of Art in 1981. Rielly's paintings form a kind of perverse family album: individuals and groups with something slightly amiss. The figures represented are composites, constructed from a variety of images from books, newspapers and magazines magnified to an imposing scale. Recently, children have most frequently populated his works: children whose uneasy attributes or strange maturity disturb the ways adults conventionally imagine and mythologise childhood. He has held fellowships at a number of institutions in Germany, the USA and in Britain, including the MOMART Fellowship at Tate Liverpool in 1995. Llandudno's Oriel Mostyn Gallery organised a major touring exhibition of his work in 2000. Rielly lives in London.

Arielle Pennanc, *James Rielly: Sensible Ways*, Musée des Beaux-Arts de Nantes, 1997

Emma Anderson, *James Rielly: Casual Influences*, Oriel Mostyn Gallery, Llandudno, 2000

Deb Rindl was born in Norwich in 1956. She graduated in graphic design from Camberwell College of Art in 1995 and went on to further study with the Buck-inghamshire Open College Network. She exhibits bookworks throughout the United Kingdom and overseas. Rindl's books are highly sculptural, with the form bearing a close relationship to the content. They are also meticulously crafted using hand-printed letterpress and are hand-folded and finished. Her work has been included in numerous group exhibitions of artist books, including at the Tate Gallery, London, 1995, *Brought to Book: Current Trends and Concepts in Book Art Production in the UK*, the Collins Gallery, Glasgow, 1995 and the Annual Wexford Artists' Books Exhibitions, Wexford Arts Centre, Ireland, 1996–2000. Rindl lives in London.

Sarah Bodman (ed.), *Books by Artists*, Impact Press/University of the West of England, Bristol, 1999

Julie Roberts was born in Fflint, Wales in 1963. She studied at Wrexham School of Art, and at Central St Martin's School of Art and Design, London, before gaining an MFA at Glasgow School of Art, 1988–90. Her first solo exhibition was at the Centre for Contemporary Arts, Glasgow in 1992 and in 1995 she was the first recipient of the Scottish Arts Council's scholarship at the British Art School in Rome. She

established her name with paintings exploring the history of medicine, including images of medical instruments and apparatus, such as operating tables and straitjackets. She has since explored the imagery of crime scenes and the mythology of characters including Freud, Darwin and Ruskin, culminating in the 1999 solo exhibition *Heroes and Villains*, at Sean Kelly Gallery, New York. She is currently participating in the International Studio and Curatorial Program in New York and divides her time between New York and Carlisle.

Andrew Cross, *Julie Roberts*, Centre for Contemporary Arts, Glasgow, 1992

Duncan Macmillan and Pat Fisher, *Julie Roberts*, Glasgow Print Studio, Glasgow, 1996

Yinka Shonibare was born in London in 1962 to Nigerian parents. He grew up in Lagos and returned to London to finish his A-levels. He studied at Byam Shaw School of Art, London, 1986–9 and Goldsmiths College, London, 1989–91. His work is primarily about identity informed by his own bi-cultural upbringing. In 1992 he won the Barclays Young Artists Award organised by the Serpentine Gallery, London. He came to widespread prominence after his work was included in the *Sensation* exhibition of Charles Saatchi's collection at the Royal Academy of Arts, London in 1997. He had a touring solo exhibition which began at the Ikon Gallery in Birmingham in 1999 and another opened at the Israel Museum, Jerusalem in 2002. Shonibare lives in London.

Alessandro Vincentelli *et al.*, *Yinka Shonibare: Dressing Down*, Ikon Gallery, Birmingham, 1998

Elena di Majo and Cristina Perrella, *Yinka Shonibare: Be-Muse*, Museo Hendrik Christian Andersen, Rome, 2001

David Shrigley was born in Macclesfield in 1968 and studied environmental art at Glasgow School of Art, 1987–91. After graduating he began publishing books of his quirky, doodle-like drawings. As well as drawing incessantly, he photographs, makes sculpture and performs 'public interventions' which he then photographs for display. His work is infused with dark, dry humour which highlights the absurdity of our everyday fears and aspirations. He had a solo exhibition at Bard College, New York in 2001 and at Camden Arts Centre, London in 2002. Shrigley lives in Glasgow.

David Shrigley, *Grip*, Pocketbooks, Edinburgh, 2000

David Shrigley, *Do Not Bend*, Redstone Press, London, 2001

Paul Simonon was born in 1955. He studied at Byam Shaw School of Art, London, 1975–6, then gave up his studies to become bass guitarist with the Punk rock band *The Clash*. He produced the cover of their album *From Here to Eternity*. Although he continued to paint during his time with The Clash it was not until their demise in 1984 that Simonon devoted himself full-time to drawing and painting. Simonon lives in London and Spain.

Pennie Smith, *The Clash: Before and After*, Plexus Publishing, Medford, New Jersey, 1994

Bob Gruen, *The Clash*, Vision-On Publishing, London, 2001

Bob and Roberta Smith are an imaginary couple created by Patrick Brill who was born in London in 1962. He graduated from the University of Reading in 1985 and gained an MA in fine art from Goldsmiths College, London, 1991–3. Bob and Roberta Smith want to spread the message that 'being creative is a really good idea', encouraging anyone to pick up the trash that surrounds them and create something new out of it. As Bob's father taught him 'Don't hate, draw. Make art, not war.' Anyone can be a Bob or Roberta Smith. Their work is imbued with humour, their world festooned with vegetables, their texts often misspelled. The work of Bob and Roberta Smith has been widely

exhibited including those at Chisenhale Gallery, London, 1997, Arnolfini Gallery, Bristol, 1997–8 and in four solo shows at the Anthony Wilkinson Gallery, London, 1994– 2002. Brill lives in London.

Bob and Roberta Smith *et al., Don't Hate Sculpt*, Chisenhale Gallery, London, 1997

Bridget Smith was born in Leigh-on-Sea, England in 1966. She spent a year at Central St Martin's School of Art and Design in London before gaining a BA at Goldsmiths College, London in 1988. She returned to Goldsmiths in 1993 to complete an MA. Her first solo exhibition was held in 1995 at Entwistle Gallery in London. In 2000 Smith received the first Tate Tokyo Residency Award, which allowed her to work in Japan for three months. She had a major solo exhibition at the Centro de Arte de Salamanca, Spain in 2002. Smith lives in London.

Thomas Seelig, *Public Relations: New British Photography*, Cantz Verlag, Ostfildern-Ruit, Germany, 1997

Bridget Smith, 'Tokyo Inside Out', *Tate: The Art Magazine*, issue 27, spring 2001

Smith / Stewart: Stephanie Smith was born in Manchester in 1968 and studied at Slade School of Fine Art, London, 1987– 90. Edward Stewart was born in Belfast in 1961 and studied at Glasgow School of Art, 1985–90. They met in 1991 while they were studying at the Rijksakademie van Beeldende Kunsten in Amsterdam, and since 1992 have worked in collaboration, mainly using video. They use themselves as their subjects, often exploring themes of pain, risk and violence. They have exhibited internationally and solo exhibitions include those held at Portikus, Frankfurt-am-Main, 1999, Galerie Bob van Orsouw, Zürich, 2000, and Chisenhale Gallery, London, 2002. In 2002 they were awarded a Henry Moore Sculpture Fellowship at the British School at Rome. Smith and Stewart live in Glasgow.

Ulrich Loock *et al., Smith / Stewart*, Fruitmarket Gallery, Edinburgh, 1998

Ulrich Loock, *Smith / Stewart: Videoarbeiten*, Portikus, Frankfurt-am-Main, 1999

Tim Staples was born in Stourport-on-Severn, Worcestershire in 1956. He studied at Hereford College of Art and Exeter College of Art. Since 1994 he has been an associate lecturer at Weston College, Weston-Super-Mare. In 1996 he participated in an international artists' exchange between Bristol and Prague. In 2001 his work was included in *A Tale of Two Cities: Bristol / New York*, an exchange exhibition of artist books by artists based in the two cities. He has produced a body of work using washers as a mark-making tool, exploring the subject of pressure, referencing the process of printmaking as well as the washer's original function. Bookworks are only a part of his artistic output; he is also a sculptor working predominantly on a small scale. Staples lives in Bristol.

John Janssen, *The Space of the Page: Sequence, Continuity and Material*, Henry Moore Institute, Leeds, 1997

Sarah Bodman (ed.), *A Tale of Two Cities: Bristol / New York*, Impact Press, Bristol, 2001

Georgina Starr was born in Leeds in 1968. She studied at Middlesex Polytechnic, 1987–9, Slade School of Fine Art, London, 1990–2 and the Rijksakademie van Beeldende Kunsten, Amsterdam, 1993–4. She works with a very broad range of materials and techniques, including video, performance, comic-strips, fashion, story boards and even musicals. One series of works concerned a parallel universe full of doppelgängers – including herself. Her work has been included in group shows such as the touring *British Art Show 4*, 1995 and *Brilliant!*, Walker Arts Center, Minneapolis, 1995. Her solo exhibitions include those held at Kunsthalle Zürich, 1995; Tate Gallery, London, 1996; Ikon

Gallery, Birmingham, 1998; Anthony Reynolds Gallery, London, 2000 and Emily Tsingou Gallery, London, 2002. Starr lives in London.

Georgina Starr *et al.*, *Georgina Starr*, Ikon Gallery, Birmingham, 1998
Georgina Starr *et al.*, *Georgina Starr: Bunny Lakes*, Emily Tsingou Gallery, London, 2002

Kerry Stewart was born in Paisley in 1965. After gaining an MA in german and art history from the University of Edinburgh she studied at Chelsea School of Art and Design, London, 1989–93. This was followed by a scholarship in Basel, Switzerland and a sculpture fellowship at Humberside University and the Yorkshire Sculpture Park, where she held her first solo show in 1995. Stewart's sculptures often resemble the simple forms of plastic toys or donation box effigies, albeit on a larger scale. They are usually crafted in plaster or fibreglass then painted, although she frequently incorporates other materials into her sculptures. While a sense of coldness and isolation pervades her work the potential for alienation from the viewer is countered by a sense of humour. Stewart has participated in many group shows, including *Young British Artists IV* at the Saatchi Gallery, London, 1995, *Correspondences* at the Scottish National Gallery of Modern Art and Berlinische Galerie, Berlin in 1997–8 and *Pictura Brittanica* at the Museum of Contemporary Art, Sydney in 1997. She had a solo exhibition, *Drops Loveliness*, at The Ballroom, Royal Festival Hall, London in 1999. Stewart lives in London.

Richard Cork, *Drops Loveliness*, Royal Festival Hall, London, 1999

Marcus Taylor was born in Belfast in 1964. He studied at Camberwell School of Art, London, 1982–6 and Slade School of Fine Art, London, 1986–8. In the 1990s he produced a celebrated series of sculptures made of acrylic sheet, which ape minimalist sculptures but are based on kitchen furniture. Taylor's work has been included in numerous group exhibitions including *Young British Artists IV*, Saatchi Gallery, London, 1995 and *Dimensions*, Städtische Kunsthalle, Mannheim, 1996. His first solo show was organised by Jay Jopling in London in 1992. Taylor lives in London.

Young British Artists IV, Saatchi Gallery, London, 1995
Pippa Coles *et al.*, *Dimensions: Fünf Künstler aus Großbritannien*, Städtische Kunsthalle, Mannheim, 1996

Sam Taylor-Wood was born in London in 1967. She studied at Goldsmiths College, London, 1987–90. Early works were made with photography, including 360° shots which built ambiguous narratives. Her recent work has included video, often using celebrities as raw material. Her solo exhibitions include those held at the Kunsthalle Zürich and Louisiana Museum of Modern Art, Humlebaek in 1997; Fondazione Prada, Milan, 1998; Hirshhorn Museum, Washington DC, 1999, and Hayward Gallery, London, 2002. She was shortlisted for the Turner Prize in 1998. Taylor-Wood lives in London.

Bruce Ferguson *et al.*, *Sam Taylor-Wood*, Fondazione Prada, Milan, 1998
Clare Carolin *et al.*, *Sam Taylor-Wood*, Steidl Publishers, Göttingen, and Hayward Gallery, London, 2002

Graeme Todd was born in Glasgow in 1962 and grew up in Cumbernauld. He gained a BA and a post-graduate diploma in painting at Duncan of Jordanstone College of Art and Design, Dundee, 1979–85. His recent work has explored a balance between landscape and monochromatic painting, based on a creative process of intuitive responses to accumulated varnished layers of marks painted in a variety of materials. His first solo exhibition was at the Seagate Gallery, Dundee in 1987 and his *Mount Hiddenabyss* works,

painted whilst on an IAAB residency in Basel in 1999, were shown at the Fruitmarket Gallery, Edinburgh in 2000. Todd teaches at Edinburgh College of Art and lives near Dunbar, East Lothian.

Pat Fisher, *Intelligible Lies*, Talbot Rice Gallery, University of Edinburgh, Edinburgh, 1998

Robert Alan Jamieson and Alan Johnston, *Mount Hiddenabyss: Graeme Todd*, Fruitmarket Gallery, Edinburgh, 2000

Gavin Turk was born in Guildford in 1967. He studied at the Royal College of Art, London, 1988–91. Turk's work deals with issues relating to art and other artists, and to institutions such as museums. His work may be read as an ironic comment on the process of artistic creation and the way its products are seen, documented and preserved. He has participated in numerous group exhibitions including *Sensation*, Royal Academy of Arts, London, 1997, *Ant Noises*, Saatchi Gallery, London, 2000 and *Century City*, Tate Modern, London, 2001. Solo exhibitions include *Signature*, Jay Jopling, London, 1992, *The Stuff Show*, South London Gallery, London, 1998 and *More Stuff*, Centre d'Art Contemporain, Geneva, 2000. Turk lives in London.

Simon Bill and Andrew Wilson, *Gavin Turk: Collected Works 1989–1993*, Jay Jopling, London, 1993

Honey Luard (ed.), *Gavin Turk: Collected Works 1993–1998*, Jay Jopling / South London Gallery, London, 1998

Alison Watt was born in Greenock in 1965. She studied painting at Glasgow School of Art, 1983–8. She first came to prominence when, still a student, she won the national portrait competition organised by the National Portrait Gallery in London. She subsequently became known for her paintings of figures, often female nudes, in light-filled rooms. She had a solo exhibition, *Shift*, at the Scottish National Gallery of Modern Art in 2000–1. In the *Shift* works Watt explored the suggestive power of fabric, sometimes in a direct reference to the clothes and furnishings in paintings by the French artist Jean-Auguste-Dominique Ingres (1780–1867). She had a solo exhibition at Dulwich Picture Gallery, London in 2002. Watt lives in Edinburgh.

Graeme Murray *et al.*, *Fold*, Fruitmarket Gallery, Edinburgh, 1997

Richard Calvocoressi and John Calcutt, *Shift: New Works by Alison Watt*, National Galleries of Scotland, Edinburgh, 2000

Gillian Wearing was born in Birmingham in 1963. She studied at Chelsea School of Art and Design, London, 1985–7 and Goldsmiths College, London, 1987–90. In 1992 she began a series of works in which she approached people in the street, gave them a sheet of paper, asked them to write something on it, and then photographed the individuals holding the message. (*Signs that say what you want them to say and not signs that say what someone else wants you to say*.) The photographs probed the gap between what a person looks like, what they might be thinking, and what we might be thinking of them. Given complete freedom to choose their own words, the people's texts, often of a confessional and intimate nature, were in turns funny, surprising, direct and strangely moving. In her video work she has explored the theme of self-awareness, and the group versus the individual. Her solo exhibitions include those held at City Racing, London, 1993; Chisenhale Gallery, London, 1997; Kunsthaus Zürich, 1997 and Serpentine Gallery, London, 2000. Wearing won the Turner Prize in 1997. She lives in London.

Russell Ferguson *et al.*, *Gillian Wearing*, Phaidon, London, 1999

Lisa G. Corrin and Carl Freedman, *Gillian Wearing*, Serpentine Gallery, London, 2000

Rachel Whiteread was born in London in 1963. She studied at Brighton Polytechnic, 1982–5 and Slade School of Fine Art,

London, 1985–7. In 1988 she began making casts of the space inside and around ordinary domestic objects, such as wardrobes, beds and baths. In 1993 she made a cement cast of the inside of an entire three-storey house in the London borough of Hackney. *House* was demolished, amidst great controversy, in 1994. Following her first solo exhibition at the Carlisle Gallery, London in 1988, she has had exhibitions at the Stedelijk van Abbesmuseum, Eindhoven, 1993, Tate Liverpool, 1996, and the Scottish National Gallery of Modern Art, 2001. She won the Turner Prize in 1994 and represented Britain at the 1997 Venice Biennale. Whiteread lives in London.

Fiona Bradley *et al.*, *Rachel Whiteread: Shedding Life*, Tate Liverpool, 1996

Lisa G. Corrin *et al.*, *Rachel Whiteread*, National Galleries of Scotland, Edinburgh, 2001

Max Wigram was born in 1966. He has been a model and also made artworks based on the theme of James Bond. He co-curated the exhibitions *Sex and the British*, at the Galerie Thaddaeus Ropac, Salzburg, Austria, 2000, and *Apocalypse*, at the Royal Academy of Arts, London, 2000. Wigram lives in London.

Craig Wood was born in Leith, Edinburgh, in 1960. He studied at Goldsmiths College, London, 1986–8. He trained as an architectural draughtsman and also made detailed drawings of archaeological finds. Subsequent to this, he made a series of works based on the enigmatic code numbers and logos printed on the plastic containers of cleaning products. Solo exhibitions include those held at Laure Genillard Gallery, 1990, Kunsthalle Nürnberg, 1993 and Oriel Mostyn Gallery, Llandudno, 2002. Wood lives in Wales.

Christine Hopfengart *et al.*, *Craig Wood, Zeichnungen*, Kunsthalle Nürnberg 1993

Jonathan Watkins *et al.*, *Craig Wood*, Oriel Mostyn Gallery, Llandudno, 2002

Richard Wright was born in London in 1960. He studied painting at Edinburgh College of Art, 1978–82. He gained an MFA at Glasgow School of Art, 1993–5, during which time he also spent a period at CAL ARTS in Los Angeles. Wright is best known for his site-specific paintings, carried out on walls or ceilings. One of his main concerns is that the works are not a commercial commodity that can be moved around and traded beyond the artist's control. The images that Wright chooses are taken from a wide range of popular and vernacular sources – club flyers, tattoos, typography, geometrical devices – a fact that stresses their links to everyday experience. Among the scholarships and awards that he has received are the Scottish Arts Council's Amsterdam residency, 1985–6, a Scottish Arts Council Award, 1997 and a Paul Hamlyn Foundation Award, 1998. He was a visiting lecturer at CAL ARTS 1999–2001 and a research fellow at Edinburgh College of Art 1999–2001. He has had numerous solo shows including those at Transmission, Glasgow, 1994; Inverleith House, Edinburgh, 1999; BQ, Cologne, 1999, and Tate Liverpool, 2001. He was included in the exhibition *Correspondences: Twelve Artists from Berlin and Scotland* held at the Berlinische Galerie, Berlin and the Scottish National Gallery of Modern Art in 1997–8. Wright lives in Glasgow.

Sugar Hiccup, Tramway, Glasgow, 1996

Richard Wright *et al.*, *Richard Wright*, Milton Keynes Gallery, Milton Keynes, 2000

Cerith Wyn Evans was born in Llanelli in 1958. He studied at Central St Martin's School of Art and Design, London, 1977–80, and at the Royal College of Art, London, 1982–4. He uses a very broad range of media, from stroboscopic lights to video, photography, mirrors and phosphorescent ink, in order to explore concepts of perception and representation. His solo exhibitions include those

held at White Cube, London, 1996, the British School at Rome 1998 and Tate Britain (*Art Now* series), 2000. He lives in London.

Marc Sladen, 'Cerith Wyn Evans', *Frieze*, no.30, 1996

Brook Adams *et al.*, *Sensation: Young British Artists from the Saatchi Collection*, Royal Academy of Arts, London, 1997

Catherine Yass was born in London in 1963. She studied at Slade School of Fine Art, London, 1982–6, and at the Hochschule der Künste, Berlin, 1984–5. After receiving a Boise Travelling Scholarship she completed an MA at Goldsmiths College, London, in 1990, and studied architecture at the Architectural Association, London, 1997–8. Yass has developed a distinctive photographic style by combining negative and positive images in a single transparency. The resulting effect echoes the Surrealists' use of solarization. The images are flooded with rich, deep colours, emphasising the constructed nature of the photographic image. Yass also uses video and film. Places such as a meat market, steel factory, synagogue and cemetery, as well as people, have all provided the artist with a source of subject matter. Her work is dominated by series of images exploring the same theme. Recently, she has turned her attention to Bollywood and its stars as seen in the work which was exhibited at the Tenth Indian Triennale, New Delhi, 2001, and is documented in the book, *Star*. In 2002, Yass was nominated for the Turner Prize, and in her solo show, *Descent*, at Asprey Jacques, London, she presented images taken from an 800 foot high crane above Canary Wharf. Yass lives in London.

Catherine Yass, *Portraits*, Aspex Visual Arts Trust, Portsmouth, 1996

Greg Hilty and Parveen Adams, *Catherine Yass*, Asprey Jacques, London, 2000

Compiled by Jane Furness, Librarian, and Logan Sisley, Archive and Library Assistant, Scottish National Gallery of Modern Art

Brook Adams *et al.*, *Sensation: Young British Artists from the Saatchi Collection*, Royal Academy of Arts, London, 1997

Katrina Brown *et al.*, *Prime*, Dundee Contemporary Arts, Dundee, 1999

Katrina Brown and Rob Tufnell (eds.), *Here and Now: Scottish Art 1990–2001*, Dundee Contemporary Arts, Dundee, 2001

Louisa Buck, *Moving Targets: a User's Guide to British Art Now*, Tate Publishing, London, 1997

Louisa Buck, *Moving Targets 2: a User's Guide to British Art Now*, Tate Publishing, London, 2000

Virginia Button, *Turner Prize*, Tate Publishing, London, 1997

Virginia Button, *Turner Prize*, Tate Publishing, London, 1999, with 2001 insert

Virginia Button and Charles Esche, *Intelligence : new British art 2000*, Tate Publishing, London, 2000

Pippa Coles *et al.*, *The British Art Show 5*, National Touring Exhibitions / Hayward Gallery, London, 2000

Matthew Collings, *Art Crazy Nation*, 21 Publishing, London, 2001

Matthew Collings, *Blimey*, 21 Publishing, London, 1997

Matthew Collings, *This is Modern Art*, Weidenfeld & Nicolson, London, 1999

Cream: Contemporary Art in Culture, Phaidon Press, London, 1998

Gemma de Cruz, *Ant Noises at the Saatchi Gallery*, Saatchi Gallery, London, 2000

Gemma de Cruz, *Ant Noises at the Saatchi Gallery 2*, Saatchi Gallery, London, 2000

Penelope Curtis (ed.), *Second Skin: Historical Life Casting and Contemporary Sculpture*, Henry Moore Institute, Leeds, 2002

Patrick Elliott (ed.), *Contemporary Art in Print: The Publications of Charles Booth-Clibborn and his Imprint The Paragon Press 1995–2000*, Booth-Clibborn Editions, London, 2001

Patrick Elliott *et al.*, *Contemporary British Art in Print: The Publications of Charles Booth-Clibborn and his Imprint The Paragon Press 1986–1995*, Scottish National Gallery of Modern Art, Edinburgh and The Paragon Press, London, 1995

Patricia Ellis, *New Labour*, Saatchi Gallery, London, 2001

Charles Esche, *Tales from the City*, Stills Gallery, Edinburgh, 1997

Zdenek Felix (ed.), *Emotion: Young British and American Art from the Goetz Collection*, Cantz Verlag, Ostfildern-Ruit, 1998

Richard Flood *et al.*, *Brilliant! New Art from London*, Walker Art Center, Minneapolis, 1995

Carl Freedman, *Minky Manky*, South London Gallery, London, 1995

Cynthia Freeland, *But is it Art?*, Oxford University Press, Oxford, 2001

Fresh Cream: Contemporary Art in Culture, Phaidon Press, London, 2000

Ann Gallagher and James Roberts (eds.), *General Release: Young British Artists at Scuola di San Pasquale, Venice*, The British Council, London, 1995

Ingvild Goetz and Christiane Meyer-Stoll (eds.), *Art from the UK*, Sammlung Goetz, Munich, 1997

Henry Meyric Hughes and Katerina Gregos, *Private Face – Urban Space: a New Generation of Artists from Britain*, The British Council/Rethymnon Centre for Contemporary Art, Greece, 1997

Iain Irving *et al.*, *This Island Earth*, An Tuireann Arts Centre, Portree, Skye, 1998

Isobel Johnstone, *The Saatchi Gift to the Arts Council Collection*, Hayward Gallery Publishing, London, 2000

Sarah Kent, *Here & Now*, Serpentine Gallery, London, 1995

Sarah Kent *et al.*, *Young British Art: The Saatchi Decade*, Booth-Clibborn Editions, London, 1999

Tania Kovatt and Irit Rogoff, *Lost*, Ikon Gallery, Birmingham, 2000

Catherine Lepdor *et al.*, *Open Country: Contemporary Scottish Artists*, Musée d'art cantonal, Lausanne, Switzerland, 2001

Rosie Millard, *The Tastemakers: UK Art Now*, Thames & Hudson, London, 2001

Bernice Murphy *et al.*, *Pictura Britannica, Art from Britain*, Museum of Contemporary Art, Sydney, 1997

Gerrie van Noord (ed.), *ICA Beck's Futures*, Institute of Contemporary Arts, London, 2000

Suzanne Pagé *et al.*, *Live/Life*, Musée d'art Moderne de la Ville de Paris, Paris, 1996

Gianni Piacentini *et al.*, *Windfall '91*, Seamen's Mission, Glasgow, 1991

Sara Roberts, *Multiple Choice: obras impresas de jovenes artistas Britanicos*, The British Council, London, 2001

Catsou Roberts and Jean-Christophe Royoux, *Perfect Speed*, Macdonald Stewart Art Centre, Guelph, Ontario, 1995

Norman Rosenthal *et al.*, *Apocalypse: Beauty and Horror in Contemporary Art*, Royal Academy of Arts, London, 2000

Andrea Schlieker (ed.), *Double Vision*, The British Council, London, 2001

Richard Shone, *Made in London: a Collection of Works by London-based Artists in the 1990s*, Simmons & Simmons, London, 1996

Julian Stallabrass, *High Art Lite: British Art in the 1990s*, Verso, London, 1999

Clare Stephenson and Anna McLauchlan, *Transmission*, Black Dog Publishing Ltd, London, 2001

Jane Warrilow *et al.*, *Locale: Contemporary Art in Edinburgh 1999*, City Art Centre, Edinburgh, 2000

Nicola White *et al.*, *New Art in Scotland*, Centre for Contemporary Arts, Glasgow, 1994

Gilda Williams (ed.), *Strange Days: British Contemporary Photography*, Edizioni Charta, Milan, 1997

Artist Books

Sarah Bodman (ed.), *Books by Artists*, Impact Press/University of the West of England, Bristol, 1999

Sarah Bodman (ed.), *Artists' Book Yearbook 2001–2002*, Impact Press, Bristol, 2001

Paul Bonaventura, *Book: David Austen, Neil Miller, Mark Wallinger, Daphne Wright*, Djanogly Art Gallery, Nottingham, 1998

Riva Castleman, *A Century of Artists' Books*, The Museum of Modern Art, New York, 1995

Johanna Drucker, *The Century of Artists' Books*, Granary Books, New York, 1995

Carol Hogben and Rowan Watson (eds.), *From Manet to Hockney: Modern Artists' Illustrated Books*, Victoria & Albert Museum, London, 1985

René Riese Hubert and Judd D. Hubert, *The Cutting Edge of Reading: Artists' Books*, Granary Books, New York, 1999

Robert Flynn Johnson, *Artists' Books in the Modern Era 1870–2000*, Thames & Hudson, London, 2002

Jean Khalfa (ed.), *The Dialogue between Painting and Poetry: Livres d'Artistes 1874–1999*, Black Apollo Press, Cambridge, 2001

Jerome Rothenberg and Steven Clay (eds.), *A Book of the Book*, Granary Books, New York, 2000

Colin Sackett (ed.), *Repetivity: Platforms and Approaches for Publishing*, Research Group for Artist's Publications, Derby, 2000

WITHDRAWN